The Eye of the Beholder

Editor
Gerald W. R. Ward *GWRW*
Assistant Curator
Garvan and Related Collections
of American Art

Contributors
Judith Bernstein *JB*
Edward S. Cooke, Jr. *ESC*
David Park Curry *DPC*
Heather Kurzbauer *HK*
Francis J. Puig *FJP*
Kevin Stayton *KS*
Diana Strazdes *DS*
Barbara McLean Ward *BMW*
Beverly Zisla Welber *BZW*

The Eye of the Beholder

Fakes, Replicas and Alterations in American Art

Yale University Art Gallery

This catalogue accompanies an exhibition held at the
Yale University Art Gallery
between 14 May and 10 July 1977

Design
Mark Ackley
Kate Emlen
Margaret Morton
Dwayne Overmyer

Printed in the United States of America

Contents

Preface

One of the primary functions of a university art museum is to help students (and the general public) to develop visual sensitivity, to discern quality, and to distinguish between the genuine and the spurious. In our era printed pictures and all kinds of imitations have become omnipresent. Cheap and inaccurate reproductions and tawdry objects intrude into our daily lives. Now more than ever it is imperative that we turn to the beautiful and carefully wrought objects of the past to train our eyes, refresh our spirits, and develop an understanding of those elusive qualities which separate the object of high quality from the mediocre. In developing connoisseurship, there is no more fruitful exercise than to try to define in words the characteristics which distinguish a major work of art from a minor one, a genuine article from a copy or forgery.

The purpose of this exhibition is to make the visitor focus on individual American art objects in order to develop an eye for the genuine. The exhibition has been prepared by a group of students and museum interns in the American Arts office, under the supervision of Theodore E. Stebbins, Jr., Curator of American Painting and Sculpture, Patricia E. Kane, Associate Curator of the Garvan Collection, and Gerald W. R. Ward, Assistant Curator of the Garvan Collection. Although Charles F. Montgomery has been on sabbatical leave this term, he played a large part in conceiving and planning the show. It should be noted that five of the contributors to the catalogue are being supported, in one way or another, by the National Endowment for the Humanities, a federal agency which has been extremely supportive of the American Arts program at Yale. Like most of the exhibitions which are produced by our American Arts office, this one involved the full collaboration of curators, faculty, and students. The students participated in choosing the objects, working on the design of the installation, and writing the catalogue. The design of the installation and catalogue were carried out as a class project under the supervision of Professor Alvin Eisenman of the Graphic Design Department of the Yale School of Art. Dextra Frankel, Visiting Lecturer in Exhibit Design at the Yale School of Art this year, and Thomas Hartman provided the students with assistance in preparing their models. Mark Ackley, Kate Emlen, Margaret Morton, and Dwayne Overmyer were selected to be the principals involved in designing the exhibition and this book.

We are extremely grateful to the people listed below for their advice, for their help in locating appropriate objects for our show, and for lending to the exhibition. We want to mention especially: Jonathan Fairbanks and Wendy Cooper of the Museum of Fine Arts, Boston; Charles Hummel, Nancy Richards, Sheri Fowble, Karol Schmiegel, and Victor Hanson of the Winterthur Museum; Samuel Sachs II of the Minneapolis Institute of Art; Margot Dennehy of the FBI; Joseph Johnson Smith and Robert Egleston of the New Haven Colony Historical Society; Lawrence Majewski of the Conservation Center, Institute of Fine Arts; Benjamin A. Hewitt; Lee Wiehl; Kenneth Newman; James Maroney; Allan Stone; Archie W. Dunn; Rainer Crone; William A. Lanford; the National Museum Act.

On the Yale Art Gallery staff, the following people contributed enormously to the success of the show: Marion Sandquist typed numerous drafts of the catalogue and handled many of the arrangements; Nancy Idaka also helped with the preparation of the catalogue, and along with Galya Gorokhoff handled much of the correspondence and many of the details; and Peter Arkell, Furniture Conservator, has prepared many of the objects for exhibition. Nan Ross, Melissa Kroning and Gail Snow of the Registrar's office have been especially tolerant of the group effort, and were unfailingly helpful. James Burke, Curator of Drawings and Prints, and Rosemary Hoffman assisted in the selection of prints, drawings and watercolors for the show. Robert Soule, Building Superintendent, and his staff have built the complex installation with their usual skill and efficiency. Elizabeth Goldstein and Joseph Szaszfai were helpful in obtaining photographs. Estelle Miehle, Administrative Assistant in the Director's office, has been helpful in all financial arrangements connected with this show.

We should also mention that Mr. and Mrs. Elias Clark, Mr. Henry Chauncey, and Dean Jaroslav Pelikan assisted us in obtaining objects on the Yale campus which were not in the Gallery proper, but which have been transferred to the Gallery for the duration of the exhibition.

Finally, we must express our thanks to the National Endowment for the Humanities for providing grants and fellowships which have made it possible for our American Arts program to flourish in the past several years. The combination of NEH funds and profits from the Gallery sales desk have made possible the publication of this volume.

Alan Shestack
Director

7

Lenders

Arthur G. Altschul
Beinecke Rare Book and Manuscript Library
Converse Memorial Library, Malden, Massachusetts
DAR Museum
Mr. and Mrs. Archibald W. Dunn
Graham Gallery
The Heckscher Museum
Benjamin A. Hewitt
The J. T. K. Hitchcock Museum
Mr. and Mrs. Raymond J. Horowitz
Conservation Center, Institute of Fine Arts,
 New York University
James Furniture Company
Herbert F. Johnson Museum of Art,
 Cornell University
Mr. and Mrs. George Kaufman
Kittinger Furniture Company
Mr. and Mrs. Charles F. Montgomery
Museum of Fine Arts, Boston
Museum of the City of New York
The New Haven Colony Historical Society
Mr. and Mrs. Jack K. Stayton
Allan Stone Gallery
Ten Eyck-Emerich Antiques, Southport, Connecticut
Tillou Gallery
Robert F. Trent
The Henry Francis du Pont Winterthur Museum
Yale University Graduate School
Private Collections

Foreword

Study of the objects in this exhibition is an exercise in seeing and of comprehension. These two activities are the foundations of connoisseurship—connoisseurship being the art and science of identification and evaluation of the qualities of works of art. In his *Two Discourses,* first published in 1719, Jonathan Richardson repeatedly emphasized the importance of close observation and good judgment. The connoisseur, he wrote,

must have a delicacy of eye to judge of harmony, and of proportion, of beauty of colours, and accuracy of hand; and lastly, he must be conversant with the better sort of people, and with the antique, or he will not be a good judge of grace and greatness.

Though his language is now archaic, Richardson's message is telling. He stated categorically,

To be able to distinguish betwixt two things of a very different species (especially if those are very much alike) is what the most stupid creature is capable of, as to say this is an oak, and that a willow; but to come into a forest of a thousand oakes, and to know how to distinguish any one leaf from all those trees from any other whatsoever . . . requires better faculties than everyone is master of; and yet this certainly may be done.

But it is on those qualities of man that bespeak the rational creature that Richardson places the greatest emphasis. For, he says,

to be a good connoisseur a man must be as free from all kinds of prejudice as possible; he must moreover, have a clear and exact way of thinking, and reasoning; he must know how to take in, and manage just ideas; and throughout he must have not only a solid, but an unbiassed judgment.

Study of objects in "The Eye of the Beholder" is a humanistic attempt to understand the nature of things. In particular it is a study of the complex relationships of objects made in the past with those more recently made, in terms of materials, form, ornament, structure, craft and technology.

The goal of the exhibition and of this catalogue is to help the observer see that objects can be fully understood only in their relationship to the society in which they were made and used. Further, it emphasizes the continuity of things and that man's creations are never wholly new but are related to earlier objects as well as to contemporary ones. Each object is part of a series.

Increasingly instruments and scientific methods are being employed to provide information about the nature of materials and how they have changed over time, and how they were made and fashioned into works of art. Again, though, it is clear that this information can only be meaningfully interpreted against the historical background of the culture in which the objects were made and used.

Charles F. Montgomery
Curator of the Garvan and
Related Collections of American Art
Professor of the History of Art

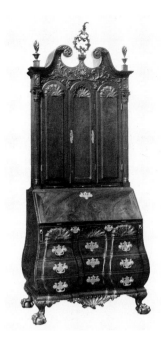

This fascinating "bombé-blockfront" desk and bookcase, with "Newport" shells and "Philadelphia" carving, ranks as an exuberant expression of the colonial revival. Made in 1942 for the collector Maxim Karolik, its present whereabouts are unknown. Courtesy, Museum of Fine Arts, Boston.

Introduction:
Fakes, Replicas and Alterations in American Art

This exhibition explores themes of concern to all who are involved in the study of American art of the last three centuries. In presenting these themes, we have arbitrarily created an organizational framework of seven categories, which we call *misattributions, alterations and adaptations, restorations, fakes, revivals, reproductions,* and *questionables*. These categories are defined in the brief essays introducing each section of this catalogue, but because our definitions are rather narrow and may differ slightly from common usage, we have provided capsule definitions of them here, as "ground rules":

Misattributions As we are using the term, a misattribution is a case of mistaken identity. In the study of the objects in this section, their traditional and generally accepted attributions have been corrected in the light of more recent investigation.

Alterations and Adaptations These objects have been modified over the years in response to changing social conditions, taste and the vicissitudes of old age; their evolution has, in a sense, been a natural one.

Restorations Examples here have been refurbished in varying degrees which reflect the changing concepts of "original" appearance. In most cases, these restora-

tions were undertaken out of concern for the care and appearance of the work, not with the intention to defraud.

Fakes These objects have been altered, married, embellished, restored, or totally fabricated with intent to deceive. Although it is often difficult to determine the presence of such intent, we have included here only works in which the desire to deceive was clearly the dominant factor in their creation or modification.

Revivals These are made in the spirit of an earlier age, and usually influenced by the styles of their own time. They often exaggerate and freely interpret the forms and ornament of the original. Our particular interest in this section is the colonial revival style.

Reproductions Closely related to revivals, reproductions are copies, duplicates, or facsimiles of works of art. They may, but need not, be made or authorized by the original artist or craftsman. We are primarily concerned here with the changes which occur in the process of reproducing a work of art, and with modern reproductions of seventeenth-and eighteenth-century objects.

Questionables These are works about which there is genuine disagreement and doubt as to their age and authenticity.

For the most part, our procedure has been to establish pairs consisting of a "real" original object and a comparable example from one of the respective categories, and to use this comparison as the basis for a discussion of their relationships.

No one realizes more clearly than the authors the difficulties involved in establishing such a system of classification. The possibilities for misunderstanding and semantic quibbling are perhaps endless. Several of our categories (such as revivals and reproductions) are closely related, and it was often difficult to know where a specific work should be included. Some of the categories work quite well for the decorative arts, but less well for paintings and prints. Many questions arose concerning the definition of a fake. We recognized that many reproductions and revivals are sold as genuine, many restorations are never pointed out to the prospective buyer, many false attributions are made to increase the value of a given work, and that it is often difficult to divine the human motives involved in the buying and selling of art. It is worth re-emphasizing that we have classed all such chicanery under the heading of "fakes," and that to the best of our knowledge the objects in our other categories represent honest, above-board creation and modification.

It has been our goal to encourage the close examination of these various types of objects, in order that we may understand them on their own terms. Central to our approach is the theory that works of art reflect the nature of the culture and society in which they are produced. Thus, although the exhibition deals with questions concerning quality, the scientific examination of works of art, and restoration philosophy and technique, it returns again and again to the humanistic premise that all objects are tangible representations of the often unarticulated cultural assumptions of a given period in history. And while a recognition of the differences in materials, techniques, and methods of construction are important, the student can often best differentiate the work of one era from that of another by an examination of those elements which, in a sense, have been added unconsciously by the maker.

This thought has guided the detection of fakes for some time. "No matter how perfectly the forger recreates the style of an ancient period, his own style is there too. It is a rule of thumb that no forgery deceives for more than a generation."[1] In other words, both the deceiver and the deceived share common views of the past, of what the original *should* look like, and frequently only the passage of time makes clear the actual differences between these perceptions and reality.

Such a rule of thumb is also applicable to those objects made in a revival style or as reproductions. As with fakes, a particularly important shaping circumstance seems to be the "sense of the past" at the time the revival or reproduction is made. For example, a slat-back side chair made between 1917 and 1936 by Wallace Nutting's company bears "little relationship to any early eighteenth century examples. Rather, it conforms to the early twentieth century concept of what such a chair looked like." These concepts are constantly changing. As Samuel Eliot Morison noted, in the 1920s the "common notion of the grim Puritan painted by J. Truslow Adams and other popular historians of the day" was of a "steeple-hatted, long-faced Puritan living in a log cabin and planning a witch-hunt or a battue of Quakers as a holiday diversion." By the 1950s, that conception had "given way to one of the jolly Puritan sitting in a little frame house furnished with early American furniture, silverware, and pewter, one arm around a pretty Priscilla and the other reaching for a jug of hard cider." Faithful copying distinguishes reproductions from revivals, but most reproductions also make concessions to these shifting "fashions in history."[2]

The study and care of objects also reflects the evolving nature of knowledge and taste. Our knowledge of the past (or rather, our lack of it) can affect the assignment of makers and origin to works of art. Many honest misattributions, made on the basis of little information, are corrected in the light of data provided by increasingly sophisticated methods of research and investigation (9). Our understanding of history and changing conceptions of "original" appearance have also affected restoration philosophy and technique. In the early twentieth century, it was thought that early Americans used only unfinished native woods in their furniture, and much original paint was removed during "restoration." Today it is recognized that this attitude was more reflective of the early twentieth-century taste for "golden oak" and the Arts and Crafts movement style than an accurate understanding of the seventeenth-and eighteenth-century aesthetic. Research has determined that paint was an essential decorative element in early American furniture, and collectors are now urged to "buy it ratty and leave it alone."[3]

Among the most interesting works of art are those which have been altered or adapted in the course of their natural evolution in response to changing social conditions and taste. Although this phenomenon is frequently encountered in architecture, it has been little explored in painting and the decorative arts. Often these altered or adapted works are accurate social barometers—they may reflect the rise of the temperance movement (24, 29) or the introduction of indoor plumbing (23). At some point, however, our attitude toward these objects changes, and they become "valuable antiques" which should be preserved.

American art is a particularly fertile field for this type of exhibition because of our fascination with our own artistic heritage and our long track record in producing fakes, revivals, and reproductions, which constitute the bulk of the exhibition. A recent study of *Art Fakes in America* asserts that our "country's artistic history reveals a record of fraud, swindling, and chicanery which is just as rich and bizarre as that established in Europe."[4] Beginning in the 1870s and continuing to the present, Americans have revived and reproduced seventeenth-and eighteenth-century designs with great vigor. This romantic admiration for the colonial arts has existed with periods of varying intensity; for example, it was particularly strong in the Depression years of the 1930s. In 1936 Wallace Nutting asserted that "no new style has been evolved that can bear comparison, side by side, for a moment, with the old styles," and he for one would "much prefer a fine reproduction to a cheap antique."[5] In the same year Nancy McClelland published an entire book setting forth principles of *Furnishing the Colonial and Federal House* (Philadelphia, 1936) with reproductions. A year later, Edgar G. Miller, Jr., noted that even though reproduction chairs had some drawbacks, they were nevertheless "the only modern ones which will give your room the dignity you wish to have."[6] And it was in 1937 that the Williamsburg Reproductions Program, the most extensive of its kind, was begun. In the 1940s, Victorian revival

furniture (86) began to be produced, and by 1950, Raymond Yates concluded "that virtually everything worthwhile and collectible is being reproduced."[7] The same conclusion is valid today. *The Old House Catalogue,* published in 1976, lists "2500 Products, Services, and Suppliers for Restoring, Decorating, and Furnishing the Period House—from Early American to 1930s Modern."[8] The mania for reproductions seems to have reached a new height with the recent appearance on the market of meticulous copies of "the classic Wallace Nutting design" windsor chair.[9] All of these objects, whether revivals or exact reproductions, stand as symbols of a conservative strain of popular culture which has been embraced by all economic classes.

The importance of fakes as guides to the understanding of what is genuine and authentic has long been recognized, and many museums, including ours, maintain study collections of fakes, alterations and reproductions as aids in increasing the awareness of students and collectors. However, many revivals and reproductions are misrepresented (either knowingly or unwittingly) as fakes, although they clearly were not made as such. Also, many of these same objects are condemned by connoisseurs as being of inferior quality and therefore unworthy of notice. As George Kubler has pointed out, "replications," a term which includes our revival and reproduction categories, can move "towards and away from quality." Without question many objects in the early American mode are commercial products which move toward what Kubler calls "tawdriness."[10] Moving in the other direction however, many revival style objects achieve a high level of quality. The best of the revivals synthesize the form and ornament of earlier times with the spirit of their own time to create new artistic statements. Heretofore, the products of the colonial revival have been regarded primarily as undesirable reproductions to be guarded against by collectors.[11] Others have explored the origins of the style,[12] and we might argue that it is a legitimate phase of the nineteenth-century revival taste. While many of its monuments have yet to be recognized, it is a style that has merit and quality in architecture,[13] and promises to have the same in the decorative arts. Our argument here is that we should not reject the colonial revival style out of hand, but try to understand the objects on their own terms and as social documents.

Despite the advances in recent years in the scientific examination of works of art, it is often the "eye of the beholder" which enables him or her to distinguish between various types of closely related objects—to separate the spurious from the genuine, to differentiate between the original and the revival or reproduction, to recognize original features and later additions or restorations, to tell the work of one artist

or craftsman from another, and to make evaluations of "good, better, and best." In those cases where science provides much of the final answer, it is usually the observer's "eye" which causes him to question an object and start the investigation.

Yet even the historian and the scientist working together cannot always determine the final answer, and even if they think they do, their successors in the next generation may reverse their decision. It is not easy to "authenticate" an object, despite popular belief to the contrary. For this reason, the exhibition closes with a painting, a pastel, and two Chippendale style chairs about which there is genuine debate and disagreement. Are they fakes or are they real? When and by whom were they created? We are not quite sure, and no one may ever be sure. It is this process of open-ended questioning and continuing re-examination which gives life and vitality to the study of objects, as we seek to reveal their varied levels of meaning and to understand them without prejudice.

Gerald W. R. Ward

Notes

1. Thomas Hoving *et. al., The Chase, the Capture: Collecting at the Metropolitan* (New York, 1975), p. 21.
2. *The American Clock 1725-1865/Forgeries and Restorations in American Furniture* (New Haven, 1974), #6 in "Forgeries and Restorations" section; Samuel Eliot Morison, "Faith of An Historian," in his *By Land and By Sea* (New York, 1953), p. 356.
3. Robert F. Trent, ed., *Pilgrim Century Furniture* (New York, 1976), pp. 7, 12; John T. Kirk, *The Impecunious Collector's Guide to American Antiques* (New York, 1976), chapter 7.
4. David L. Goodrich, *Art Fakes in America* (New York, 1973), p. 9.
5. [Wallace Nutting], *Wallace Nutting's Biography* (Framingham, Massachusetts, 1936), pp. 126,107.
6. *American Antique Furniture*, 2 vols. (New York, 1937), 1: 29.
7. *Antique Fakes and Their Detection* (New York, 1950), p. 130.
8. Lawrence Grow, comp., *The Old House Catalogue* (New York, 1976).
9. Advertisement of the Windsor Chair Shop, Epping, New Hampshire, in *American Antiques* 5, no. 2 (February 1977): 49.
10. George Kubler, *The Shape of Time* (New Haven, 1973), p. 76.
11. For instance, see the report in *The Gray Letter* 2, no. 7 (February 14, 1977): 3.
12. Rodris Roth, "The Colonial Revival and 'Centennial Furniture'," *The Art Quarterly* 27, no. 1 (1964): 57-81.
13. Particularly in the work of McKim, Mead, and White.

Rhode Island block-and-shell furniture is considered by some to be "the most original furniture form produced in eighteenth century America."[1] With their vertical blocking surmounted by richly carved shells, examples such as this bureau table (1) are among the most beautiful and sought after types of early American furniture. Beauty, rarity, and high market price combine to make it an object worthy of the skillful faker's attention.

It has recently been determined that the second bureau table (2) is a fake. Without opening its drawers or cupboard door, one can see evidence which reveals the modern origin of this piece. It is out of scale with original examples (1), and its blocking and carving are lifeless. Conscious of imitating an original, the carver felt constrained and his efforts lack creativity. The surface does not move in undulating, baroque curves, and the shells are less ample and poorly integrated into the facade.

The maker of this piece used old wood in its construction, but all of the interior wood is rough, and there are holes, scratches, and other signs of wear in unexpected and illogical places. Although the woods have not yet undergone microanalysis, it appears that the maker used a number of coniferous woods not encountered in Newport furniture. *GWRW*

1. Charles F. Montgomery, "Regional Preferences and Characteristics in American Decorative Arts: 1750-1800," in Charles F. Montgomery and Patricia E. Kane, eds., *American Art: 1750-1800, Towards Independence* (Boston, 1976), p. 59.

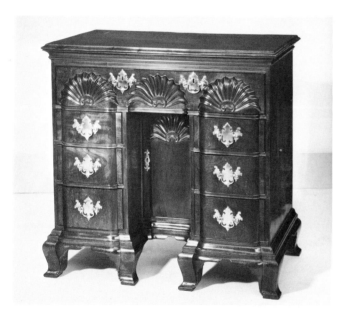

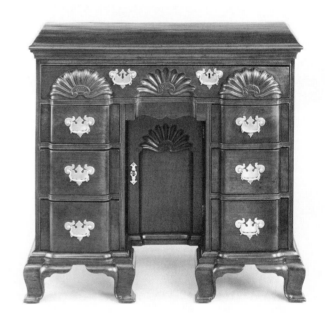

1
Bureau table *1957.37*
Possibly by the Goddard-Townsend family
Newport, Rhode Island, 1755-1795
Mahogany; tulip, chestnut
H. 34 1/8" (86.7 cm); W. 37 1/2" (95.3 cm);
D. 20 3/4" (52.7 cm)
Yale University Art Gallery;
Mabel Brady Garvan Collection

2
Bureau table *1976.108*
American, 20th century
Mahogany; white pine and other conifers
H. 33 1/8" (84.1 cm); W. 36 5/8" (93 cm);
D. 19 1/2" (49.6 cm)
Study Collection, Yale University Art Gallery

The makers of revival style objects frequently take great liberties in interpreting the forms and decorative elements of the older objects which are their inspiration. This revival bureau table (3), probably made in about 1900, has two carved shells on its recessed cupboard door. A concave shell of the type found on eighteenth century Philadelphia furniture is topped by a convex shell similar to those found on Massachusetts furniture of the same period, a combination not encountered in the eighteenth century.

In contrast, the Kittinger Company claims to take no such freedom of interpretation. Their chest of drawers (4) is described as an "authentic reproduction" of a Newport chest of about 1760 bearing the label of John Townsend.[1] In keeping with the Kittinger philosophy of reproductions, it is designed as "a faithful, handsome replica of the original in the smallest detail." Kittinger suggests that "to the modern householder, hard pressed to find genuine eighteenth century antiques, these mellowing reproductions will become more cherished day by day. Truly they are the heirlooms of the future."[2] This attitude, and the emphasis on handwork, and exact copying of "timeless traditional designs" suggests the romantic spirit behind all such reproductions.
GWRW

1. The original is illustrated in Ralph E. Carpenter, Jr., *The Arts and Crafts of Newport, Rhode Island, 1640-1820* (Newport, 1954), p. 65.
2. The Kittinger Company, *A Library of 18th-Century English and American Designs* (Buffalo, New York, 1976), p. 4. The chest is illustrated and discussed on pp. 94-95.

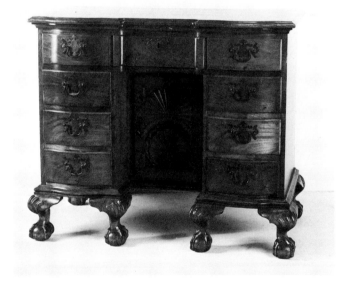

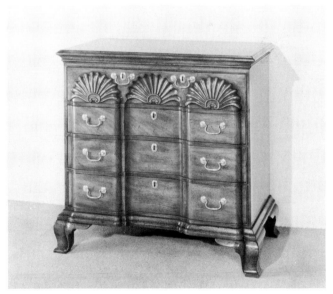

3
Bureau table *1939.559*
American, probably late 19th century
Mahogany; tulip
H. 31 1/2" (80 cm); W. 38" (96.5 cm);
D. 20 3/8" (51.8 cm)
Yale University Art Gallery;
deLancey Kountze, B. A. 1899, Collection

4
Chest of drawers
Kittinger Furniture Company
Buffalo, New York, ca. 1976
Mahogany; tulip, pine
H. 34 1/2" (87.7 cm); W. 37 3/4" (95.9 cm);
D. 21" (54.3 cm)
Kittinger Furniture Company

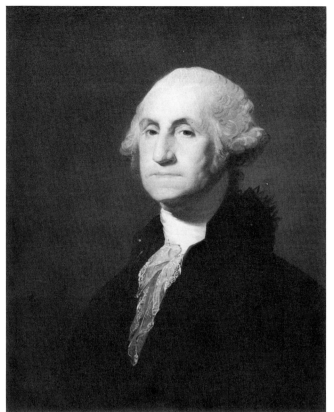

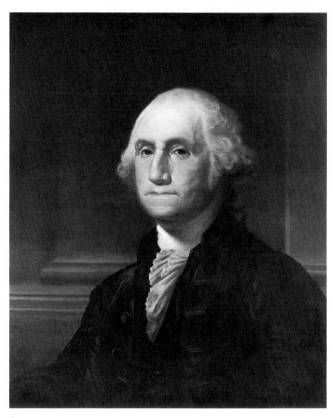

5
Gilbert Stuart (1755-1828) *1931.157*
George Washington
Oil on canvas, early 19th century
H. 29 5/16" (74.9 cm); W. 28 1/8" (71.4 cm)
Yale University Art Gallery;
bequest of Chauncey M. Depew, Jr.

6
Unknown
George Washington
Oil on canvas, ca. 1815
H. 30" (76.2 cm); W. 25" (63.5 cm)
Tillou Gallery

Although George Washington was painted by many contemporary artists, including John Trumbull and several members of the Peale family, the most popular image of Washington as the statesman and leader of America over the past two hundred years has been defined in the portraits of Gilbert Stuart. The four paintings included here reveal much about the nature of reproduction in art, since they are all copies of an original Stuart portrait. Beginning in 1795, Stuart painted Washington three times from life, both in bust and full length portrait styles. He personally may have copied these portraits up to forty times. In both Europe and America it was a common practice for artists to copy paintings originally commissioned by other patrons. In this sense the artist created his or her own reproductions. Stuart's best known version of Washington is his second life portrait, the 1796 *Atheneum Portrait* (Museum of Fine Arts, Boston) of which the Yale replica is accepted as a direct copy.

Sometimes Stuart became mechanical in his copies of Washington. However, both the Yale version (5) and the unknown portrait (6) are carefully and skillfully rendered. Because this portrait (6) lacks

provenance and the painting style is somewhat atypical of Stuart, it is difficult to determine whether it is actually by Stuart's hand. Yale's Stuart is much more thinly painted than the second example, which is more finished and has red underpainting, rather than Stuart's usual white. Both the ground and the greater concern for details of dress and background suggest an attribution to Rembrandt Peale. Experts have disagreed as to who painted this version. The majority conclude that it is probably by Stuart, but others suggest that Peale is the artist.

In contrast, the portrait (7) by Jane Stuart, Gilbert's daughter, is a student work. Jane had minimal training from her father, who died when she was sixteen, and she learned to paint by copying his portraits, making several of her own replicas of Washington. Stuart's skillful handling of his medium and the immediacy of image are lost when translated into Jane's version, a phenomenon often observable in student works. Nevertheless, Jane maintained a naturalness and care of depiction, qualities not found in the extremely wooden and unrealistic Chinese copy (8). This reverse painting on glass, by an

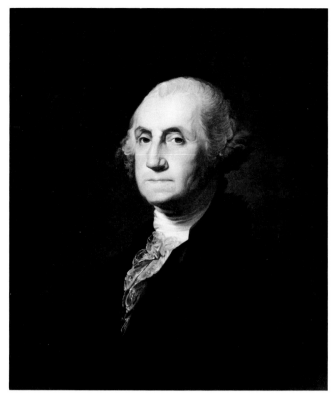

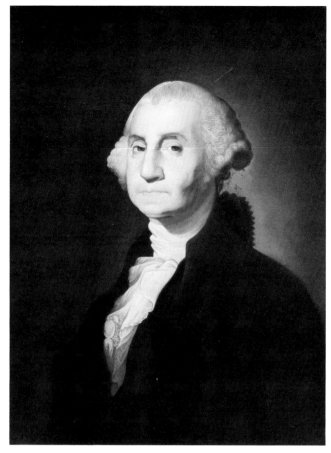

7
Jane Stuart (1812-1888)
George Washington
Oil on canvas, mid-19th century
H. 30" (76.2 cm); W. 25" (63.5 cm)
Courtesy, Graham Gallery

8
Unknown Chinest artist *1932.277*
George Washington
Oil on glass, early 19th century
H. 29" (73.7 cm); W. 22" (55.8 cm)
Yale University Art Gallery;
Mabel Brady Garvan Collection

unknown artist, demonstrates the popularity of
Stuart's portrait of Washington two hundred years
ago. It was one of the many objects that the Chinese
produced for the American market as part of an
extensive import trade that flourished from the 1780s
through the 1850s. Chinese artists, catering to
American taste, painted portraits of Western subjects
and copied Western prints and paintings onto sheets
of glass.[1] Sometimes these works were of high quality
and have been misattributed to American artists. This
painting, however, reveals the limitations of an artist
who lacked technical facility and who painted for a
different culture the portrait of a man he had never
seen. *JB*

1. Carl L. Crossman, *The China Trade: Export Paintings,
Furniture, Silver and Other Objects* (Princeton, New Jersey,
1972), p. 123.

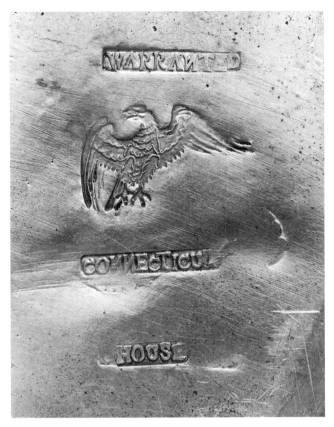

11

Misattributions

Misattributions are cases of mistaken identity that occur when a work of art is erroneously believed to have been created by a different artist, in a different location, or in a different period than is actually the case. Misattributions usually are made with unsigned works of art, but they may also take place when marks or signatures are mistakenly identified. The incorrect attribution is an honest, unwitting, mistake.[1]

The identification of works of art with a particular artist, location, or date depends upon the information available at the time. Attribution had little importance in the study of American art until the late nineteenth century when art historical documentation seriously began. As research and scholarship yields new information, old attributions are constantly challenged. Helen Comstock has noted that since the appearance in 1928 and 1933 of Wallace Nutting's pioneering three volume *Furniture Treasury,* "much has been learned . . . and consequently the book contains what must be called errors today."[2]

Society's worship of a name is revealed in the overzealous practice of identifying objects with famous artists or makers. Sometimes, when the names of only a few artists or makers of a period are known, an attribution can be optimistically given to a work of art that has some elements in common with documented examples.

A classic example of such blanket attributions is Vernon Stoneman's book on John and Thomas Seymour of Boston, where over two-hundred and thirty pieces of furniture made in New England between 1795 and 1820 are attributed to the Seymours although only four had been documented and two labeled.[3] Since furniture associated with the Seymours was of exceptionally fine quality and had brought record prices in the 1930s, there was a natural inclination to define the Seymours' oeuvre. Stoneman's attempt, undisciplined in its scope, confused a regional style with an individual firm.[4] Since eighteenth-century and early nineteenth-century furniture makers working in one geographic location shared skills and materials, the problem of attributing an individual object to a specific maker on the basis of details of construction and ornament is very difficult. Sound attribution of authorship for unsigned objects usually must rely upon documentation. A well-known case in point is the misattribution of the carving on a Federal style chest-on-chest at the Yale University Art Gallery to Samuel McIntire because of its stylistic similarity to a chest-on-chest in the Museum of Fine Arts, Boston known to have been carved by McIntire.[5] This attribution on the basis of visual analysis was overthrown by Mabel Swan. Through the discovery of bills for making and carving a chest of drawers from the Dorchester cabinet-maker Stephen Badlam and the Boston carvers John and Simeon Skillin to Elias Hasket Derby, the original owner of the chest, she was able to prove that these Boston area craftsmen were the actual makers.[6]

Artists working within the same school, studying together, or being exposed to common influences may create works of art closely resembling each other. Students who work closely with a teacher may absorb his style so completely that their works can not always be distinguished from those of their master without other evidence (19, 20).

For much of our history, American artists and craftsmen were dependent on Europe for style, iconography, and technique, and hence there is often a close correlation between European and American objects. At times, American objects can be confused with European pieces: provincial English or Irish furniture can closely resemble American pieces, and paintings by Americans working abroad can be very similar to the work of their foreign contemporaries. For example, the now-famous full-length portrait of William Grant, *The Skater* (National Gallery of Art, Washington, D.C.), was painted by Gilbert Stuart in 1782 while he was still in Britain. It went into an English collection, and when it was exhibited at the Royal Academy in London in 1878 it was misattributed to Thomas Gainsborough (1727-1788), the great English landscape artist and portraitist.[7] More commonly, European objects are mistakenly considered to be American. For example, the portrait

by the French artist Louis L. Boilly (17) was long thought to have been painted by the American artist John Vanderlyn. Instances of European objects being identified as American are even more frequent with decorative arts than with paintings. Not only were makers sometimes immigrants who had developed their skills in Europe, but stylistic ties to England and the Continent were maintained through the use of European and English pattern books and imported pieces as well. Glass, rarely signed or given a distinguishing mark, is a material that is particularly difficult to identify as to place of origin.[8] For instance, one American glassmaker, Henry William Stiegel, copied European methods of manufacture and styles so faithfully that work from his glass house is difficult to distinguish from European pieces (13, 14).[9]

Although misattributions in paintings and prints generally arise when a work is unsigned, there are exceptions. An unusual case is that of the genre and still-life painter, De Scott Evans (1847-1898), whose use of pseudonyms was responsible for confusion and misunderstanding surrounding his work. Evans, born David Scott Evans, signed his portraits and genre scenes "De Scott Evans." He used this signature on one trompe-l'oeil, but all his others appear with initials or with various pseudonyms: Scott David, Stanley David, and S. S. David.[10] Apparently Evans used his aliases to hide the fact that in addition to his academic genre pieces he was painting trompe l'oeil still-lifes, a genre held in low esteem in the late nineteenth century. For many years Evans and the various "Davids" were thought to be different artists and only recently have the many signatures been connected with this single figure.[11]

The discovery and correction of a misattribution does not change the work of art, but it may change the object's historical significance or its monetary value, depending on the reputation of the actual artist or maker. Generally the successful detection of misattributions increases our understanding of an artist, a period, or a region. The study of American art, history, and society involves a continuous process of learning and reevaluation. Additional discoveries will be made in the future, and some of the attributions that we take for granted today will be found to be in error and in need of correction.

Judith Bernstein

Notes

1. For the purposes of this exhibition deliberate misattributions are considered fakes.
2. Helen Comstock, "Wallace Nutting and the *Furniture Treasury* in retrospect," *Antiques* 80, no. 5 (November 1961): 462.
3. Vernon C. Stoneman, *John and Thomas Seymour: Cabinetmakers in Boston 1794-1816* (Boston, Massachusetts, 1959).
4. Richard H. Randall, Jr., "Works of Boston Cabinetmakers, 1795-1825: Part I and II," *Antiques* 81, no. 2 and 4 (February and April 1962).
5. Fiske Kimball, "Some Carved Figures by Samuel McIntire," *Bulletin of the Metropolitan Museum of Art* 18 (August 1923): 194-196.
6. Mabel M. Swan, "A Revised Estimate of McIntire," *Antiques* 20, no. 6 (December 1931): 338-343.
7. Barbara Novak, *American Painting of the Nineteenth Century* (New York, 1969), p. 32.
8. Paul N. Perrot, "Glass: English, Irish, or American?" *Antiques* 79, no. 3 (March 1961): 265-266.
9. George S. and Helen McKearin, *American Glass* (New York, 1941), p. 68.
10. Nancy Troy, "From the Peanut Gallery: The Rediscovery of DeScott Evans," *Yale University Art Gallery Bulletin*, in press.
11. William H. Gerdts and Russell Burke, *American Still-life Painting* (New York, 1971), pp. 167-168.

The table (9) bearing an authentic label of the New York cabinetmaker George Shipley was recently auctioned as a New York table, though it has ornamental and construction features which suggest it was made in Rhode Island.[1] Since Rhode Island furniture was shipped to New York in the Federal period, this table may have been part of that trade.[2]

A quantification procedure, currently being used in the study of Federal period card tables, corroborates the hypothesis that the labeled New York table was probably made by a Rhode Island artisan.[3] By gathering extensive evidence on characteristics of twelve Rhode Island and twelve New York card tables of the era, and comparing the data to that of the labeled Shipley table, it was found that the Shipley table corresponds more closely to Rhode Island furniture-making practices than to those employed in New York. Thus, an authentic label from a city does not necessarily prove that the object was made in that location, but if an object has been made in one region and sold in another, that information is an important part of its history. In the future, methods of analysis borrowed from other disciplines may be expected to provide information to confirm or refute attributions made on the basis of stylistic evidence. *BZW*

1. Charles F. Montgomery, *American Furniture: The Federal Period* (New York, 1966), pp. 319-342.
2. Joseph K. Ott, "Exports of Furniture, Chaises and Other Wooden Forms from Providence and Newport, 1783-1795," *Antiques* 107, no. 1 (January 1975): 136-141.
3. From unpublished research being conducted by Benjamin A. Hewitt, New Haven, Connecticut. Mr. Hewitt has isolated 176 characteristics of materials, construction, decoration and design which can be used to codify further the consistent features of Federal card tables.

9
Card table
With the label of George Shipley of New York
Rhode Island, ca. 1795
Mahogany; white pine, cherry, cherry inlay
H. 28 1/4" (71.8 cm); W. 36" (91.4 cm);
D. 35 9/16" (86.3 cm)
Benjamin A. Hewitt

10
Card table
Rhode Island, ca. 1795
Mahogany; white pine, cherry, satinwood inlay
H. 28 15/16" (73.5 cm); W. 36" (91.4 cm);
D. 35 11/16" (86.6 cm)
Benjamin A. Hewitt

In 1924 J. B. Kerfoot presented the concept that American pewter is more valuable or less valuable according to the identity of the maker.[1] As a result collectors try to identify their pewter. This plate (11), with an eagle touch between "WARRANTED" and "CONNECTICUT/HOUSE," demonstrates the premium placed on marks.[2] Dealers and collectors who were eager to identify this mark attributed it to Edwin House, a pewterer who worked in Hartford, Connecticut between 1841 and 1846. However, such features as the heavy weight, the off-center touch, and the backward Ns in "CONNECTICUT" and "WARRANTED" pointed to twentieth-century manufacture. When the director of the Hitchcock Museum was queried, the mystery was solved. About 1960, the Hitchcock Chair Company's showroom, the "Connecticut House," sold reproduction pewter pieces with this mark, a touch purposely designed to insure that the pieces would not be mistaken as old. This plate illustrates the dangers inherent in making attributions, especially in pairing the name of a maker and a mark in the absence of sound documentation. *ESC*

1. J. B. Kerfoot, *American Pewter* (Boston, 1924), pp. 216-220.
2. Robert Mallory III, "Fakes and Falsies," *Pewter Collectors' Club of America Bulletin* 45 (September 1961): 94-97.

11
Pewter plate (see p. 18)
The Hitchcock Chair Company
Riverton, Connecticut, ca. 1960
Diam. 7 1/2" (19.1 cm)
The J. T. K. Hitchcock Museum

Before 1967 it was hoped that the shielded "H. I." mark on these sauce boats was that of an unidentified American pewterer. His touch was found on other pieces that were believed to be American, such as cream pitchers and pear-shaped teapots,[1] and one writer even suggested that the mark represented the partnership of Gershom Jones and Samuel Hamlin, both of whom worked in Providence, Rhode Island.[2] The noted pewter scholar Ledlie Laughlin also suggested they might be American.[3] However, no documented American sauce boats of this style exist, and the mark "H. I." is topped by features found on both English and American pewter, an "X" quality mark and a crown. On the basis of this meagre evidence, no definite conclusions could be reached as to their place of origin. Finally, the discovery in 1967 of another pair of sauce boats, one with the identical "H. I." mark and the other with the full name of Henry Joseph, a London pewterer of the mid-eighteenth century, revealed that these sauce boats were actually made in England.[4] *ESC*

1. John Carl Thomas, " 'H. I.' — An Answer — And an End," *The Pewter Collectors' Club of American Bulletin* 56 (June 1967): 132.
2. *The Pewter Collectors' Club of America Bulletin* 45 (September 1961): 98.
3. Ledlie Laughlin, *Pewter in America*, 3 vols. (Boston, 1940-1970), I, plate XLII, figure 273.
4. Thomas, p. 133.

12
Pair of pewter sauce boats
Henry Joseph, w. 1740-1780
London, ca. 1740-1780
H. 3 11/16" (9.4 cm); W. 6 1/4" (15.9 cm)
Study Collection,
The Henry Francis du Pont Winterthur Museum

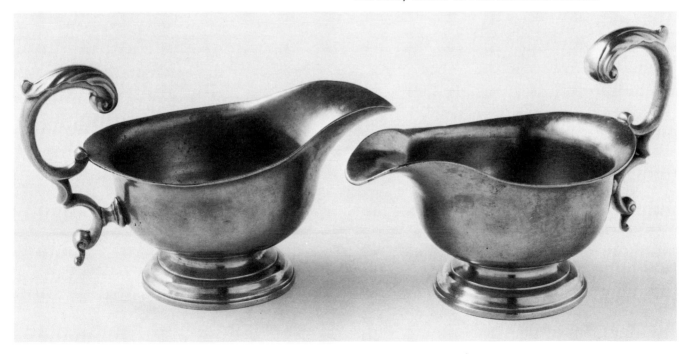

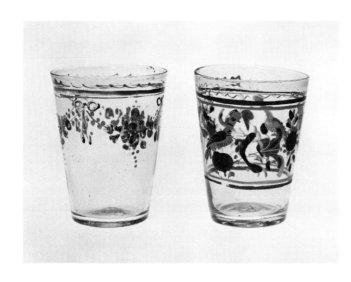

13
Enameled glass tumbler *1930.1569*
European, late 18th or early 19th century
H. 3 13/16" (9.7 cm); Diam. lip 3 1/8" (8 cm);
Diam. base 2" (5.2 cm)
Yale University Art Gallery;
Mabel Brady Garvan Collection

14
Enameled glass tumbler *1930.1816*
Pennsylvania, 1765-1785
H. 3 3/4" (9.6 cm); Diam. lip 3 1/4" (8 cm);
Diam. base 2" (5.2 cm)
Yale University Art Gallery;
Mabel Brady Garvan Collection

When Henry William Stiegel set up his glassworks in
Manheim, Pennsylvania in the 1760s, he introduced
enameled glass which would appeal to the immigrant
German population of the area. Their preference for
bright colors and the inclusion of birds, flowers,
leaves, hearts, and baskets is reflected in Stiegel's
decorative repertoire.

The comparable size, form, use of flowers and
colors render these two tumblers very similar, making
the misattribution of the European example (13) as
American understandable.[1] However, differences are
apparent in the character of their enameled decora-
tion. The European tumbler employs a limited
decorative vocabulary of flowers and bows. The
Stiegel-type tumbler (14) includes numerous
naturalistic motives, among them birds, flowers, and
baskets. Also, the decoration of the European
tumbler is confined to a small area near the upper
rim. The American counterpart, as is frequently true,
yields much of its surface to decoration. Moreover,
the decoration of the European tumbler is executed
in a refined fashion, whereas the painting on the
American tumbler is more crudely articulated.

Transplanted artisans working for transplanted
ethnic groups predictably carried on traditions they
learned in Europe for customers whose tastes were
formed in Europe. This combination continues to
make it difficult to discriminate between glass made
in this country and the very similar glass made
abroad. *BZW*

1. McKearin, *American Glass*, pp. 64-74, 87-88.

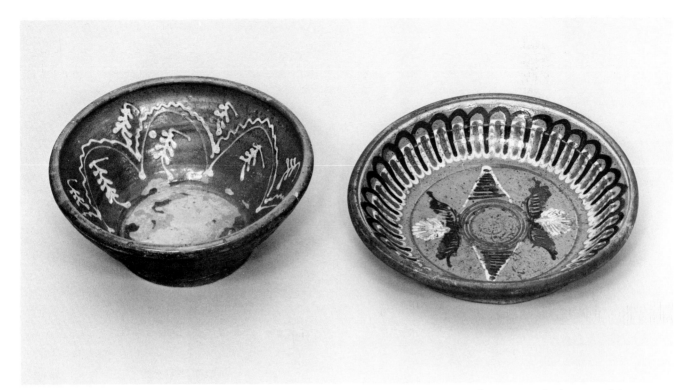

15
Redware bowl
Probably Portuguese, 19th century
H. 4 3/4" (12.1 cm); Diam. 12" (30.5 cm)
Study Collection, Yale University Art Gallery

1972.134.3

16
Redware bowl
Possibly by Peter Schmidt
Possibly Winesburg, Ohio, 1795-1830
H. 2 7/8" (7.3 cm); Diam. 13 3/8" (34 cm)
Yale University Art Gallery;
Mabel Brady Garvan Collection

1931.1820

Portuguese pottery is commonly imported into America today, where it may be mistaken as American in origin. Although upon cursory examination this Portuguese bowl (15) appears similar to an American nineteenth-century bowl (16), there are a number of differences in its outline, finishing, and decoration which point to foreign potting traditions.[1] Perhaps the most obvious mark of foreign origin is the Portuguese bowl's rim which turns inward, not outward as on American examples. The use of a foot such as is found on this example is also very unusual in American ware. More commonly American bowls have no foot at all, or when present are better defined. The exterior finish of the two bowls is also different in that the American example was smoothed on the exterior before firing; the Portuguese bowl was not. Further, the slip trailing on the Portuguese bowl is nervous in quality, in contrast with the deliberate, even application of slip to the American piece. Another characteristic of Portuguese pottery is that the slip decoration is not pressed into the clay surface before firing and feels bumpy to the touch. American potters traditionally pressed their decoration into the clay to keep it from chipping off in use. *FJP*

1. This information was provided to the author by Joseph Johnson Smith, author of *Regional Aspects of American Folk Pottery* (York, Pennsylvania, 1974). Mr. Smith is currently Director of the New Haven Colony Historical Society, New Haven, Connecticut.

This portrait of Joseph Reade (17) was for many years attributed to John Vanderlyn on the basis of its stylistic similarities to Vanderlyn's known works (18) and because the inscription "Painted by John Vanderlyn" is written on the back of its canvas. Vanderlyn painted numerous small bust-length portraits in this style, and the inscription is in handwriting very similar to Vanderlyn's own.

It was not until 1975 that this traditional attribution was challenged, and the painting re-assigned to the French painter Boilly.[1] Although Vanderlyn's early French style is similar to Boilly's leathery surfaces, *Joseph Reade* has a stronger kinship to Boilly's own work, which includes over 5,000 small portraits in this manner. In addition, the H-shaped stretcher supporting *Joseph Reade* is a particular type used by Boilly and not by Vanderlyn. The inscription may have been added by an early owner who was unaware of the correct authorship.

17
Louis L. Boilly (1761-1845) *1949.265*
Joseph Reade
Oil on canvas, early 19th century
H. 8 7/8" (22.5 cm); W. 6 3/4" (17.1 cm)
Yale University Art Gallery;
gift of Mrs. Francis P. Garvan

Misattribution of European paintings to American artists happens often with painters such as Vanderlyn, who assimilated European styles. Unlike the misattribution problem involved in distinguishing the work of pupils and followers from masters (19, 20), there was no intention on Boilly's part to resemble Vanderlyn. The mistake occurred because of the tendency of owners to assume that their unsigned paintings are done by the best-known and most famous of possible makers. *DS*

1. Kenneth D. Lindsay, "John Vanderlyn in Retrospect," *The American Art Review* 7, no. 2 (November 1975): 82.

18
John Vanderlyn (1775-1852) *1952.32.1*
Elias Boudinot
Oil on panel, 1821
H. 8" (20.2 cm); W. 6 1/8" (15.5 cm)
Yale University Art Gallery;
gift of Mrs. W. P. Belknap

Once considered a self-portrait by William Merritt Chase, this painting (19) was recently assigned to Chase's pupil Annie Traquair Lang.[1] Lang studied with Chase at the Pennsylvania Academy from 1906-1910 and also attended his famous Shinnecock Hills summer school.[2]

Lang's portrait of her teacher bears the teacher's impress, although Chase by no means encouraged imitation. Her work shares with Chase's own portrait of Alfred Stieglitz (20) the sense of character rapidly recorded with vigorous brushwork. The direct gazes of the sitters, their boldly silhouetted heads, and the economy of detail in both portraits stem ultimately from Chase's 1870 Munich sojourn. Along with other expatriates, he adopted *alla prima* painting, that is, completing works in a single session, with little emphasis on underdrawing. Depicting Chase's white hat and suit, Lang owes less to Chase than to the international style practiced by portraitists like John Singer Sargent and Giovanni Boldini. Lang had also studied with Cecilia Beaux, a practitioner of this international style. In long buttery strokes made with a wide brush, Lang recalls Beaux's elegant handling of paint.[3]

Lang wielded the brush less surely than either of her teachers, however. Although Chase's free brush-stroke retains a sense of edge and control, visible in Stieglitz's mustache and face, Lang's brushwork is softer and its impact depends more upon a lavish Beaux-like use of paint for its own sake. *DPC*

1. Sotheby Parke Bernet, Sale Catalogue, no. 3823, 1975, lot 83.
2. Ronald G. Pisano, *The Students of William Merritt Chase* (Huntington, New York, 1973), p. 29; and Downtown Branch, Whitney Museum of American Art, *19th Century American Women Artists* (New York, 1976), p. 6.
3. See Beaux's portrait, *Man with the Cat* (1898) in Frank H. Goodyear and Elizabeth Bailey, *Cecilia Beaux: Portrait of an Artist* (Philadelphia, 1974), p. 94.

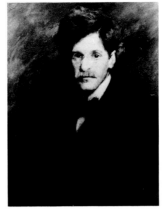

20
William Merritt Chase (1849-1916) *1949.179*
Alfred Stieglitz
Oil on canvas, 1905
H. 29" (76.2 cm); W. 21 1/2" (63.5 cm)
Yale University Art Gallery; Alfred Stieglitz Archive, gift of Georgia O'Keeffe

21
Willem de Kooning (b. 1904)?
Study for Harry Jackson (not illustrated)
Pencil on vellum, 1949
H. 16" (40.8 cm); W. 13" (32.2 cm)
Allan Stone Gallery

Harry Jackson, the original owner of this unsigned pencil study, has claimed that it is a drawing by Willem de Kooning, but de Kooning himself denies that it is his. This unusual situation is documented in a letter of 1962 which Jackson, who had recently sold the study through Barbara and Bob Kulicke, wrote to de Kooning. Jackson's letter describes "the circumstances under which you did actually make this pencil drawing Back in 1949 . . . you came over to the studio and . . . made a pencil drawing to show me . . . how to see one form growing out of and lapping over another one I understand that the Kulickes arranged for you to see the drawing a couple of months ago and you denied it was yours." In a second letter Jackson speaks more disparagingly about de Kooning's refutation of the work.[1]

Ordinarily, written documentation serves as one means of establishing the authorship of a work, but in this case, the letter confuses rather than clarifies the problem. The authorship remains a curious puzzle. The lower left corner of the sketch which, perhaps, once had a signature, has been ripped away. The drawing style appears to be atypical of de Kooning and, in fact, the present owner has suggested that the study might be by Larry Rivers (b. 1923). *JB*

1. The letters are in the possession of Allan Stone; there is some ambiguity about the identity of the recipient of the second letter since it is simply addressed to "Barbara." In all likelihood this is Barbara Kulicke.

19
Annie Traquair Lang (1885-1918)
Portrait of William Merritt Chase
Oil on canvas, ca. 1910
H. 30" (76.2 cm); W. 25" (63.5 cm), cut down
Collection of Mr. and Mrs. Raymond J. Horowitz

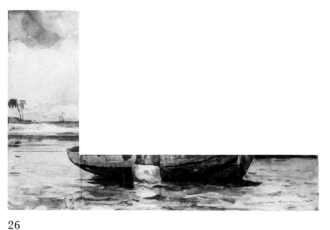

26

Alterations and Adaptations

Because possessions have traditionally been valued for their utility in America, Americans have had few hesitations about altering things that have fallen out of use. In the interest of economy, objects tended to be adapted rather than discarded.

The treatment of their houses is among the earliest and strongest traditions of American alteration and adaptation. For example, lean-tos were often added to seventeenth-century New England houses when more space was needed. Extra parlors, butteries, sheds and workshops were sometimes added to the same house in the eighteenth and nineteenth centuries, dwarfing the modest dwelling that started it all. Casement windows were replaced by double-hung sash windows which let in more light. Later, in the mid-nineteenth century, when the veranda became a popular feature of new houses, they were also added to old ones. "Gingerbread" appeared not only on Andrew Jackson Downing's cottages, but also on the facades of earlier Georgian houses. When these and other changes were made, it was not considered important that the original façade or contours of the house were lost. Form was malleable to the exigencies of function. Coinciding with these exterior and structural alterations, fashions in wallpaper design, paint colors, and interior moldings were also changing.

There is evidence that the early American attitude toward furniture was equally utilitarian. Charles Montgomery has noted that repairs took up as much or more of an eighteenth-century cabinetmaker's time as did the making of new furniture, particularly in rural areas.[1] A brisk business in repairs implies that old furniture was kept and re-used. A habit of re-use is the breeding ground for adaptations and alterations.

The addition or removal of certain parts was one way to adapt furniture. Rockers were placed on chairs, and commode chairs' deep skirts were cut off (23), so their presence in parlors would be less embarrassing. Cornices on secretaries and corner cupboards were cut off to fit them into low-ceilinged

rooms. Because the design of brasses changed stylistically, old ones were often removed from case pieces, and new, more up-to-date ones were added. Necessary repainting was often the chance for an owner to make an old piece more stylish. Queen Anne side chairs were frequently painted or japanned around 1810, when painted fancy chairs were popular.[2] Adding upholstery was another common form of adaptation. In 1869, Catherine Beecher and Harriet Beecher Stowe suggested a simple way to adapt old furniture:

If you have in the house any broken-down arm chair, reposing in the oblivion of the garret, draw it out— drive a nail here and there to hold it firm—stuff and pad, and stick the padding through with a long upholsterer's needle, and cover it with chintz like your other furniture. Presto—you create an easy-chair. Thus can broken and disgraced furniture reappear, and, being put into uniform with the general suit of your room, take on a new lease on life.[3]

Adaptations of silver usually involved the addition of pieces, particularly spouts and handles, that were cast separately and affixed with solder. Such changes generally left the main body of the piece intact. Silver beakers, commonly used as seventeenth-century communion vessels, were occasionally given handles in the eighteenth century. Little thought was given to whether or not the early beakers were designed to bear them. During the Victorian period, the use of individual communion cups replaced the custom of drinking out of a common vessel, and spouts were frequently added to communion tankards, adapting them to a new function.[4] Reworking silver was also part of a silversmith's work during the eighteenth century.[5] Reworking—principally the addition of repoussé ornament—was even more widely practiced during the rococo revival of the 1860s.[6]

Textiles, perhaps more than other forms of art, have frequently been altered. It was thought that old cloth should be used and re-used until it wore out. As a result, it is not uncommon to find seventeenth-century linen towels made into Victorian anti-macassars, eighteenth-century coverlets made into piano shawls, and crewel pockets turned into knitting bags.

The alterations and adaptations discussed so far have either increased an object's usefulness or brought it up to current fashion. A second category of adaptations has to do with an almost excessive respect for an object's preciousness, which grew out of the eclecticism of the last quarter of the nineteenth century and the first quarter of the twentieth century.

In the *Decorator and Furnisher* of 1887 the William B. Savage Company, Boston, advertised an "Old Flax Spinning Wheel Chair" that was "novel, artistic, durable A Beautiful Wedding or Birthday Present."[7] The chair was essentially an

expression of nostalgia. Turning old spinning wheels into chairs assured their visibility for those who wanted to meditate on things past, for spinning wheels no longer had a functional place in the home.

This spirit of combining old and new elements was carried to an extreme by several early collectors. Between 1895 and 1915, Henry Davis Sleeper built his summer home in Gloucester, "Beauport," using woodwork from colonial and federal houses.[8] In Boston during the early 1900s, Isabella Stewart Gardner used antique marble columns as door jambs in her new palace on the Fenway. (When one broke during construction, she had it replaced in plaster. No one noticed.) Following a Venetian custom, she used a Roman sarcophagus as a fountain in her courtyard.[9] Etta and Claribel Cone, art collectors from Baltimore, set their dining room table with a favorite antique altar cloth.[10]

Alterations of paintings and drawings were made less frequently, perhaps because people were likely to feel that their own innocent tampering would decrease a painting's value. Nevertheless, alterations occurred, the cutting down of paintings being among the most common.

Printmakers were responsible for some intriguing alterations of their own prints, especially those made to suit changing public taste. Currier and Ives, more than any other firm, catered to a general audience and were therefore especially sensitive to shifts in public opinion, as can be seen in the differences between their 1848 and 1876 versions of Washington's farewell toast to his officers (32, 33). Their trotting prints were also altered to keep up with technical changes in the sport. In 1890 they published a large horse racing scene, *A Race for Blood,* which showed three trotters and their drivers head on. In 1892, low rubber wheels replaced the old high wheels on sulkies. The same *Race for Blood* was reissued in 1894, the only change being the substitution of the new wheels for the old.[11]

Alterations generally cause problems in restoration. In many cases, such as altered engraving, cut-down paintings, or furniture with missing legs or feet, the dismembered part no longer exists. Is it reasonable to try to reconstruct the whole? If not, what is the value of the piece that remains? Furniture that has had successive coats of paint, houses that have gradually evolved, and silver that has been embellished, all present a mixed blessing for the restorer. Although the original object lies beneath the layers of additions, how much to remove becomes a difficult question. The problem becomes especially difficult the earlier the alterations were made, for one must ask which version should be saved.

Diana Strazdes

Notes

1. Charles F. Montgomery, *American Furniture, The Federal Period, 1788-1825* (New York, 1966), p. 11.
2. Dean A. Fales, Jr., *American Painted Furniture 1660-1880* (New York, 1972), pp. 67, 72.
3. Catherine E. Beecher and Harriet Beecher Stowe, *The American Woman's Home* (New York, 1869), p. 89.
4. Martha Gandy Fales, *Early American Silver* (New York, 1970), p. 275.
5. Rita Susswein Gottesman, comp., *The Arts and Crafts in New York 1726-1776* (New York, 1938), p. 55.
6. M. G. Fales, *Early American Silver,* p. 274.
7. Robert Bishop, *How to Know American Antique Furniture* (New York, 1973), p. 191.
8. Charles B. Hosmer, Jr., *Presence of the Past* (New York, 1965), p. 212.
9. Louise Hall Tharp, *Mrs. Jack* (Boston, 1965), pp. 219, 238.
10. Barbara Pollack, *The Collectors: Dr. Claribel and Miss Etta Cone* (New York, 1962), pp. 133, 218.
11. Frederic A. Conningham, *Currier and Ives, An Illustrated Checklist* (New York, 1970), p. 218.

These roundabout chairs have undergone alterations which reflect changing cultural preferences about decoration or function.[1] The first chair (22) was repainted in the nineteenth century in the then current fashion for painting wood to look like highly figured maple. The old reddish-brown paint is visible beneath the later cream and brown graining. The application of paint represents a continuation of the tradition of painting furniture to make it appear to be made of a more costly or exotic wood. These additional coats of paint in newer colors and fashions are an alteration which many pieces of eighteenth-century furniture have undergone over time, and represent part of their cumulative history.

The other roundabout chair (23) has suffered a structural alteration. The chair was originally made as a commode chair, with pendant seat rails to conceal a chamber pot. In the nineteenth century, with the introduction of indoor plumbing, the sanitary role of commode chairs became outmoded, both functionally and socially. Therefore, they were often modified, as this example has been, by the excision of the deep skirt from the seat rails.[2] The removal of the skirt rendered the chair more socially acceptable for use in the parlor, without any reminders of one of its former roles. *BZW*

1. Patricia E. Kane, *300 Years of American Seating Furniture: Chairs and Beds from the Mabel Brady Garvan and Other Collections at Yale University* (Boston, 1976), nos. 78 and 120 (hereafter cited as Kane, *Seating Furniture*).
2. W. M. Horner, Jr., "A Survey of American 'Wing Chairs'," *International Studio* 99, no. 410 (July 1931): 71.

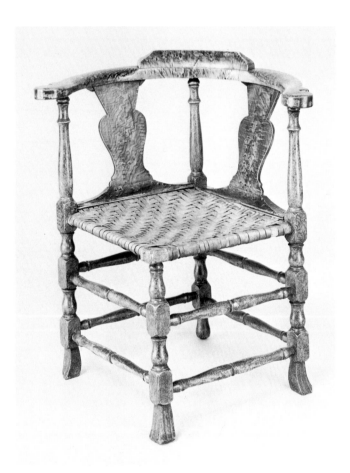

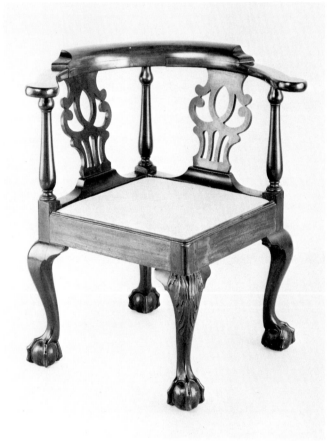

22
Roundabout chair *1930.2434*
New England, 1730-1750
Soft maple
H. 30 7/8" (77.2 cm); W. 16 5/8" (42.2 cm);
D. 17" (43.2 cm)
Yale University Art Gallery;
Mabel Brady Garvan Collection

23
Roundabout chair *1930.2695*
New York, 1760-1780
Mahogany; white pine, tulip
H. 30 13/16" (78.3 cm); W. 18 5/8" (47.3 cm);
D. 18 13/16" (47.8 cm)
Yale University Art Gallery;
Mabel Brady Garvan Collection

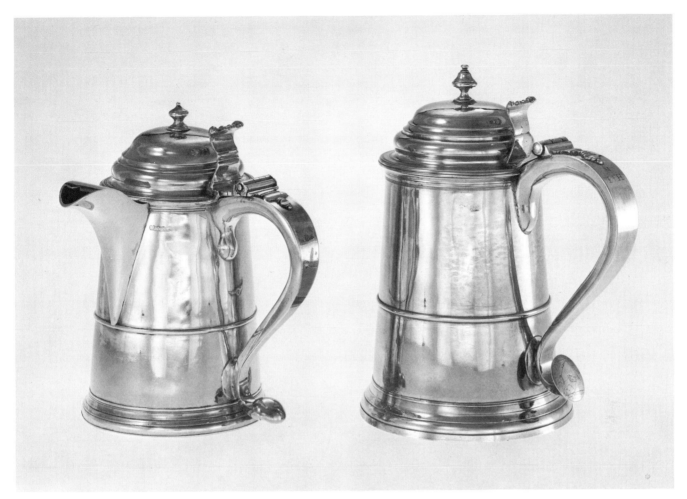

Tankards were a very popular form of communal drinking vessel in the seventeenth and eighteenth centuries. Passed among friends in the tavern or home, they usually had a large capacity, sometimes holding as much as a gallon of liquid. Perhaps because of their large size, or because the temperance movement made them unfashionable, tankards were often converted to pitchers in the nineteenth century through the addition of a spout to the front or the side of the body (24). E. Alfred Jones pictures some tankards in *The Old Silver of American Churches* which also were altered in this way for communion purposes, presumably at about the same time.[1] When silver tankards became valued as antiques, owners and dealers began to restore them to their original appearance (38). More recently, an appreciation for the need to preserve alterations made over time has prompted museums to retain the added spout on some examples. The silver tankard (25) by John Burt is a tankard of similar form and date which never had a spout.[2] *BMW*

1. E. Alfred Jones, *The Old Silver of American Churches* (London, 1913), pp. xl-xliv, lxxiii-lxxx, 7-8, 92, 188, 325-326, 481-482.
2. Kathryn C. Buhler and Graham Hood, *American Silver, Garvan and Other Collections in the Yale University Art Gallery* (New Haven, 1970), no. 127, no. 114 (hereafter cited as Buhler and Hood, *American Silver*).

24
Silver tankard with added spout *1930.1198*
John Potwine (1698-1792)
Boston, ca. 1730-1735, spout probably added 1840-1880
H. 7 3/8" (18.7 cm); Diam. lip 3 3/4" (9.5 cm);
Diam. base 4 3/4" (12.1 cm); WT. 23 oz, 5 dwt (721 gm)
Yale University Art Gallery;
Mabel Brady Garvan Collection

25
Silver tankard *1930.1195*
John Burt (1693-1746)
Boston, ca. 1745
H. 8 1/4" (21 cm); Diam. lip 4 1/16" (10.3 cm);
Diam. base 5 7/16" (13.8 cm); WT. 25 oz, 4 dwt (781 gm)
Yale University Art Gallery;
Mabel Brady Garvan Collection

26
Winslow Homer (1836-1910) *1965.33.13a,b*
Bahamas Scene, fragment (see p. 26)
Water color on paper, 1885
Upright section H. 12 1/8" (30.5 cm); W. 4 1/2" (11.4 cm);
horizontal section H. 3 1/2" (8.9 cm); W. 15 1/2" (39.4 cm)
Yale University Art Gallery;
gift of Allen Evarts Foster, B.A. 1906

These fragments (26) of a Winslow Homer watercolor present an interesting and unusual problem. Why was it cut in this particular way? The watercolor may have been accidentally damaged, but since the missing two-thirds of the work, whose whereabouts are unknown, must contain its central subject, the alteration was probably intentional. Perhaps the artist, dissatisfied with the composition, altered it himself. Or perhaps a subsequent owner, who placed little artistic value on the work in its original form, cut it down to fit a smaller frame. Whoever took the missing piece had little concern in having a work signed by Homer, since the signature "Winslow Homer 1885" remains in the lower right hand corner of the fragment. Whatever the reason for this mutilation, the manner in which the watercolor was cut down is peculiar. The remaining fragments depict a black man pushing the hull of a rowboat. Yet the figure is cut off at mid-body, so that in the missing piece he must appear as half a figure, without any sense of placement. *JB and HK*

In contrast to the small, inexpensive pictures that formed the mainstay of Currier and Ives' lithographic production, their large folio editions were based on the work of leading painters. The clipper ships have been among the most consistently popular of these. The large folio versions of clipper ships appeared from 1852 to 1856, the *Flying Cloud* being among the first three published. The original painting for the lithograph was by James E. Buttersworth who made this subject his specialty.

When the Currier and Ives firm closed in 1907, their lithographic stones were sold. Six of the clipper ship stones came into the possession of Max Williams, a print dealer, who made a number of prints (27) from them around 1915. These impressions have gradually become valuable in their own right.

Williams's impression shows a number of alterations. Some were due to wear on the stone; for instance, the ship on the horizon at the right is nearly eradicated and the legend is faint. The rigging has been reworked to make it darker. Other changes were made without regard to details in the original lithograph. Buttersworth's signature was painted over. The tiny men on deck were not colored as they were on the original. The original thin ribbing on the hull is obscured.

The coloristic differences between the two prints are striking—the newer one is much brighter than the original. The Currier and Ives' hand-coloring process, although based on the original painting, produced variations from print to print.[1] This example is particularly muted. Max Williams almost surely did not follow this procedure and his impressions do not reflect the green gray tones of Buttersworth's painting. *DS*

1. Harry T. Peters, *Currier and Ives, Printmakers to the American People*, 2 vols. (Garden City, New York, 1942), 1: 34.

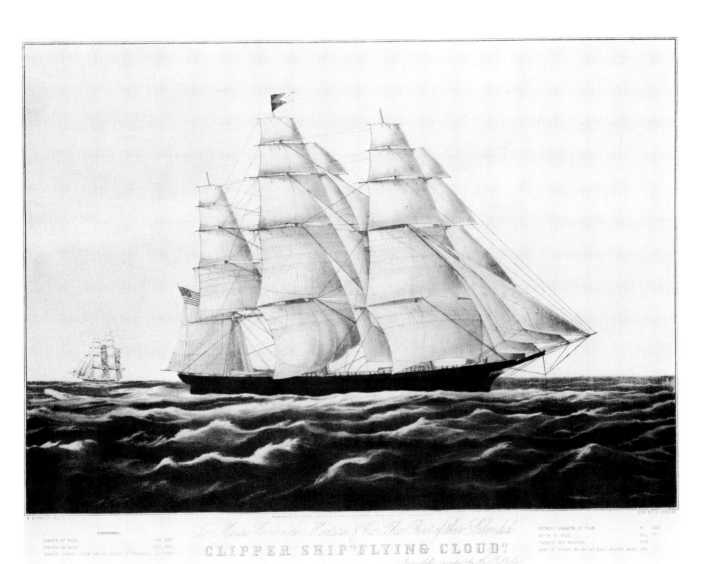

CLIPPER SHIP "FLYING CLOUD"

CLIPPER SHIP "FLYING CLOUD"

27
Max Williams, after N. Currier, publisher
Clipper Ship "Flying Cloud"
Lithograph, ca. 1915
H. 16 1/2" (41.9 cm); W. 24" (60.9 cm)
Ten Eyck-Emerich Antiques, Southport, Connecticut

28
Nathaniel Currier, publisher
Clipper Ship "Flying Cloud"
Lithograph, 1852
H. 16 1/2" (41.9 cm); W. 24" (60.9 cm)
Yale University Art Gallery;
Mabel Brady Garvan Collection

1946.9.1185

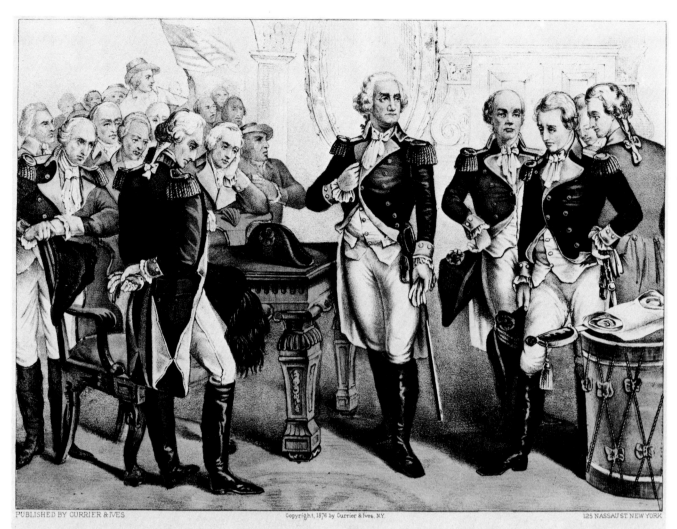

WASHINGTON'S FAREWELL TO THE OFFICERS OF HIS ARMY.

At the old Tavern, corner Broad and Pearl Sts. New York, Dec. 4th 1783.

Entering the Room where they were awaiting him, Washington said, "With a heart full of love and gratitude I now take leave of you." Knox turned and grasped his hand, and while tears flowed from the eyes of both, the Commander-in-chief kissed him; this he did to each of his Officers. The scene was one of great tenderness. *Marshall's Life of Washington.*

29
Currier and Ives, publisher
Washington's Farewell to the Officers of His Army,
Lithograph, 1876
H. 8 3/4" (22.2 cm); W. 12 1/8" (30.8 cm)
Museum of the City of New York;
Gerald LeVino Collection

30
Nathaniel Currier, publisher
Washington Taking Leave of the Officers of His Army,
Lithograph, 1848
H. 8 1/2" (21.6 cm); W. 12 3/8" (31.5 cm)
Museum of the City of New York;
Harry T. Peters Collection

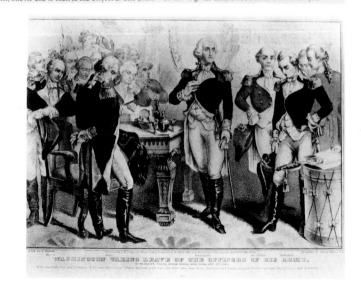

Two types of prints provided the chief source of income for the Currier and Ives firm: illustrations of news stories which were known as "rush stock," and small, cheap "stock prints" such as the two shown here.[1] Since the firm kept and re-used its most popular stones, some were altered to suit the changing public taste. Examples of this are the 1848 and 1876 versions of the lithographs showing Washington's farewell to his officers. Details of the later version (29), issued during the centennial year, were considerably changed. The borders have been enlarged, making the American flag more prominent. Some heads have been reworked and the wording of the title sentimentalized. The coloring is cruder. For example, the rug is a flat monochrome, while in the 1848 version (30), the different colors in the design were carefully depicted.

The most obvious alteration is the removal of the wine glasses and decanter from the table, probably in response to the growth of the temperance movement during the 1870s. In 1872 the first National Prohibition Party was founded. It placed prohibition candidates on the presidential ballot in the elections of 1872 and 1876, and transformed temperance from a private matter to a potent national political issue. *DS*

1. Peters, *Currier and Ives*, 1: 40.

Small, round inexpensive papier mâché snuff boxes (32) were common in America in the late eighteenth and early nineteenth centuries. The lids of these snuff boxes were decorated to simulate popular paintings. In the early nineteenth century, these included female figures recalling Renaissance and contemporary portraits. Both these objects (31, 32) have such pseudo-portrait decoration.

The first example (31) was given to Yale as an example of a primitive portrait miniature. In this case, however, the "miniature" is actually the painting on a snuff box cover, which has been cut out and placed in a frame. The miniature's back reveals its origin, for miniatures were painted on ivory, or sometimes paper, but never on black papier mâché.

This snuff box lid was probably altered in this fashion after 1850, when smoking replaced snuff-taking and snuff boxes became obsolete. Although framed to resemble a miniature, this assemblage differs significantly from miniatures' traditional function. True miniatures were portraits, not stock images, and were usually kept covered, not framed and hung on a wall.

However, by the mid-1800s, the attitude toward miniatures had changed. No longer meant for private viewing, they were considered pictures in their own right. Miniatures were now collected, and the identity of the sitter was no longer essential to their appeal. This use of a snuff box lid as a miniature was a natural consequence of this changing attitude. *DS*

31
Snuff box lid, framed as a miniature *1976.105.8*
Probably English, ca. 1830, and 20th century
H. 4 1/2" (11.8 cm); W. 4 1/2" (11.8 cm)
Yale University Art Gallery;
bequest of Bradford F. Swan

32
Papier mâché snuff box (not illustrated)
Probably English, ca. 1830
H. 7/8" (2.2 cm); Diam. 3 1/2" (8.9 cm)
DAR Museum;
gift of Mrs. Minnie Blodgett

40a

Restorations

Few museum visitors realize that most of the objects which they see on display have undergone some degree of restoration or conservation. As works of art grow older, they need care and attention to survive. All objects accumulate dirt and dust and each medium responds to changes in temperature and humidity in its own way. Under certain circumstances pigments deteriorate and flake from the surfaces of paintings, pastels and furniture. Canvases are sometimes affected by mold and mildew, and wood can become infested with worms or dry rot. Accidents occur which make conservation measures essential (40, 40a). The cleaning and restoration of works of art also involve questions of ethics and aesthetics. Although scientific aids in the examination of works of art have helped to reduce the modern restorers' chances of error, controversy continues over the extent of restoration which is advisable or permissible.

In the late nineteenth century, whole new pieces were sometimes constructed from surviving fragments. Charles Eastlake complained that, "a fragment of Jacobean woodcarving, or a single 'linen fold' panel is frequently considered a sufficient authority for the construction of a massive sideboard."[1] Large areas of loss often were overpainted by restorers and damaged sections of panel paintings are known to have been completely replaced. Such extensive reworking created objects (36, 48) which were either totally new artistic statements, or which contained anachronistic and inappropriate elements.

The prevailing theory of furniture restoration in America at the beginning of the twentieth century was to return pieces, as nearly as possible to the appearance which they had when new (33), removing all signs of damage and wear.[2] Because this practice often resulted in the removal of original finish and trim, some collectors of the 1920s and 1930s were led to the conviction that furniture should not be restored at all. These collectors sought to buy only pieces which were in a remarkably good state of preservation. Fragments and damaged objects however, had little value and were, for the most part, sold at low prices to casual buyers interested in home furnishings. Unscrupulous dealers, on the other hand, deceived their customers by concealing major replacements and selling heavily restored objects as "untouched" and "in original condition."[3]

In 1930 Henry Hammond Taylor urged his readers to consider which pieces they wished to collect, "the later things which may often be found whole and sound; or . . . the more or less wrecked earlier pieces which may require considerable restoration."[4] Although Taylor cautioned against removing the evidences of age and use in the process of restoration, he still treated the replacement of feet and small missing parts as routine maintenance. He was willing to accept more extensive restoration of older pieces and formal mahogany furniture than he recommended for nineteenth-century pieces or simple furniture made of native woods.[5] Although many of his methods seem overzealous today, Taylor's restoration philosophy was conservative for its time. The abuses which he mentions in his book give us some idea of the quantity of furniture which was stripped and planed so that it would shine like a reproduction.

In actual fact few objects have survived totally intact. Many pieces were repaired several times during the life of their original owner. Silversmiths' account books indicate that repair work often accounted for much of a man's business. Thus the question continually arises of what is original and what is not, on any given object. Good modern restorers change only what they must in order to unify and stabilize a work of art, recognizing that substantial alterations are difficult to reverse in the light of future discoveries. Much care is taken in refinishing old surfaces[6] and parts are generally only replaced when the design of an object is bilaterally symmetrical and the appearance of the missing piece is therefore readily discernible from existing evidence. Earlier restorations are seldom removed but are merely treated as later alterations.

The major concern at the present time is to preserve what is left of an object rather than to restore it to its "original" appearance. As an example of this philosophy, the later paint on the roundabout chair (22) has been retained because it is a significant expression of American taste and contributes to the history of the object. Other alterations, such as the

addition of a spout to a silver tankard (24) are evidences of change in social customs. This object is now a better record in terms of social history than tankards which have been restored (37, 38), but its original appearance has been changed significantly. Decorative arts objects were made to be useful as well as beautiful, and therefore changes in their use are of great importance. Once a spout or new engraving is added to a piece, neither can be completely removed without further damaging the object's "original" appearance (37, 38), and yet opinions concerning this type of restoration vary tremendously. If the object in question was a painting, such as Quidor's *Ichabod Crane* (43), later alterations would probably be removed on the basis that they were not part of the artist's original conception.

In the restoration of paintings, additions made to a canvas over the original paint (43) can be removed through careful cleaning. The restorer must take careful precautions to avoid removing any additions which might have been made by the artist himself, but the technology now exists to do the work safely following proper examination. In the early twentieth century restorers were reluctant to remove old yellowed varnishes because the "romantic golden glow" which they gave to the works of the Old Masters was so valued by collectors and connoisseurs. Often this glow was actually augmented by the addition of tinted varnishes to the already yellowed surface.[7] In recent years however, most art historians have reached the conclusion that these dirty varnishes actually distort the color and composition of the work of art as it was created originally (41, 42). The recent cleaning of several of John Trumbull's works has resulted in a new appreciation of his subtle and fresh coloristic techniques and has provided art historians with valuable new information.[8]

The cleaning of paintings is now accepted as common practice by most museums. Nevertheless it has been argued that often the thin glazes used by some artists as finishing touches to their work are removed along with the yellowed varnishes during the process of cleaning, resulting in heavy damage to the paintings. However, others insist that restorers with proper knowledge of the artist's method of working, and close scrutiny and careful testing of the canvas before cleaning, can avoid such accidents. Restorers and conservators have made great strides in recent years in the improvement of scientific aids for examining and analyzing works of art, and they have been active in developing professional training programs in the field.[9]

Some restorers and art historians believe that paintings should be cleaned to the bone and left in that state, so that the museum visitor will see only what is original. This is in part a reaction to early restoration techniques in which restorers blended the areas of inpainting over areas of original paint, thus obscuring the master's work. There is, however,

always a danger of removing too much, and generally if it appears that the removal of later inpainting will in any way damage original material, it is not cleaned away. New inpainting is done sparingly and is "confined to the exact area of loss," the purpose of which "is to distract attention from the blemish, not to conceal it completely."[10] After the work is done it is now customary to cover the painting with a thin, easily removable, synthetic varnish.

Much analysis and investigation is involved in the restoration of any work of art. Sometimes extraordinary problems require special measures for which there are no precedents. Every object presents a new problem which must be dealt with individually and therefore restoration practice can only be studied by the case method. However, several principles are generally observed. Everything which the conservator does must be reversible, and only materials which can be removed without damaging the original parts of the object should be used. The integrity of the work of art is always paramount, and any addition to the object is done to unify it as a work of art for the viewer, without deceiving students and collectors. Meticulous record-keeping is all important, and thorough written and photographic records are of immense value in the future, particularly since the original portions of the object may only be clearly visible during the restoration process. The primary function of any treatment is to preserve and stabilize the components of the object and to contribute to the knowledge and appreciation of the original work of art.[11]

Barbara McLean Ward

Notes

1. Charles Eastlake, *Hints on Household Taste* (1878; reprint ed., New York, 1969), pp. 64-65.
2. Robert F. Trent, ed., *Pilgrim Century Furniture* (New York, 1976), pp. 7, 12.
3. This information was provided by Charles F. Montgomery.
4. Henry Hammond Taylor, *Knowing, Collecting and Restoring Early American Furniture* (New York, 1930), p. 23.
5. Taylor, *Knowing, Collecting and Restoring Early American Furniture*, pp. 23-38, 46-82.
6. "Conservation of Furniture, Preservation or Restoration" in John D. Morse, ed., *Country Cabinetwork and Simply City Furniture* (Charlottesville, Virginia, 1970), pp. 296-299.
7. Helmut Ruhemann, *The Cleaning of Paintings, Problems and Potentialities* (New York, 1968), pp. 41-53.
8. Irma B. Jaffe, *John Trumbull: Patriot-Artist of the American Revolution* (Boston, 1975), pp. 104-115.
9. Ruhemann, *The Cleaning of Paintings,* pp. 254-267, and Theodor Siegl, *Conservation at the Philadelphia Museum of Art* (Philadelphia, 1966), pp. 129-139.
10. Siegl, *Conservation,* p. 139.
11. These guidelines are largely derived from Siegl, *Conservation,* pp. 129-139, and from statements by Jonathan Fairbanks printed in Morse, *Country Cabinetwork,* p. 294.

Philosophies of restoration have not always been as cautious as they are today. In the nineteenth century, the restorer's goal in "reviving"[1] a piece was often to make it appear as it did when it was new; there was sometimes a lack of respect for the integrity of an object and its development through time. This cupboard was owned by the early collector Henry F. G. Waters whose general policy in restoration was to clean an object to the bone, removing turned parts and sanding them on a lathe to fresh, new forms.[2] Worn parts were replaced, painted areas repainted and wear simulated on the resulting new surfaces. In this way the forms intended by the original craftsman were lost.[3] Unfortunately, this cupboard suffered just that fate. What we see today is a combination of old parts heavily reworked and refinished and nineteenth-century replacements. The black paint smeared on the turnings, grooves and applied bosses is supposed to appear as worn paint, but it is far from convincing.

The pine top, the dentils, and some of the appliques and turnings (now affixed with machine-cut square nails) are replacements, as is the framing member to the left of the top drawer. This piece of wood shows worm channels on its surface, indicating that it was made from old lumber. *KS*

1. Dean A. Fales, Jr., *The Furniture of Historic Deerfield* (New York, 1976), p. 179.
2. Richard Saunders, "Collecting American Decorative Art in New England," *Antiques* 109, no. 5 (May 1976): 996-1003 and 110, no. 4 (October 1976): 754-763.
3. John Kirk, *Early American Furniture* (New York, 1970), p. 191.

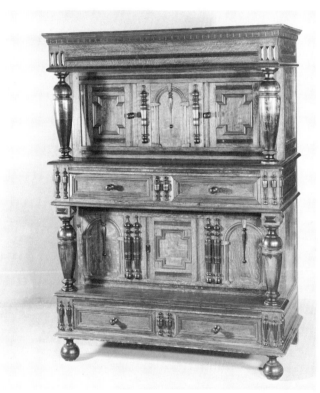

33 *1930.2778*
Cupboard
Eastern Massachusetts, 1670-1710; restored ca. 1890
Oak; pine, maple
H. 63 1/8" (160.3 cm); W. 47" (119.4 cm);
D. 23 3/4" (60.3 cm)
Yale University Art Gallery;
Mabel Brady Garvan Collection

As in the case of the cupboard (33) many new pieces have been added to this windsor armchair (34). These include some of the spindles, all the feet from the ring and spool turnings downward, both knuckled handholds, and the crest rail. Clues to these restorations are that the bottoms of the feet are not very worn and that the joining of the new and old parts is apparent above the ring and spool turning on each leg. The restoration of the knuckled handholds can be detected by the lines where the old and new parts join just above the arm supports. The thickness, sharp edges, and hard-looking surface of the crest rail lead to the conclusion that it, too, is a replacement.

The restorations give the chair a unified look. Unlike the cupboard, which has been restored to the point of looking new, the chair represents a different attitude toward restoration: the old parts have not been skinned to look new. But how much of the chair is, in fact, old is called into question by the abundance of the already-discovered restorations. *BZW*

Extensively damaged by fire several years ago, this chair was a candidate for unusually drastic restoration. The entire carcass of the chair and its upholstery were scorched and charred and the right leg and stretcher were beyond repair. Using the other parts of the chair as models, the restorer, Mr. Robert Walker of the Museum of Fine Arts, Boston, skillfully turned and carved matching replacement pieces. The parts of the chair to be covered with upholstery were smoothed down and then built back up with sawdust and glue and covered with canvas to make a solid foundation of the proper contour. After the blackened portions were sanded smooth, a base coat of whitish alcohol stain was applied to the surface to neutralize the blackish color. The whole chair was then refinished with an oil stain and shellac. This chair has been more extensively restored than is the general practice with museum objects but it was undertaken because the chair belongs to a private collector who wished to have it repaired for sentimental and practical reasons. *BMW*

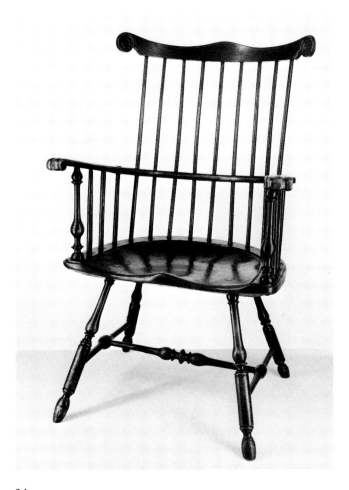

34
Windsor armchair
Pennsylvania, 1765-1800
Maple, oak, tulip, ash
H. 41 15/16" (106.5 cm); W. 28 1/16" (71.3 cm);
D. 25 1/2" (64.8 cm)
Study Collection,
The Henry Francis du Pont Winterthur Museum

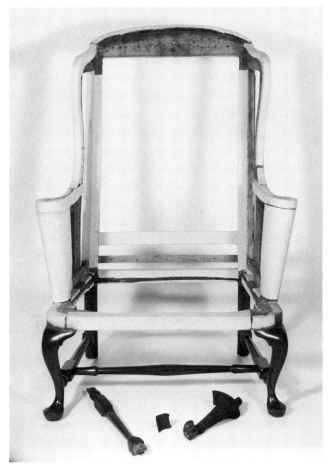

35
Easy chair with restored right leg and stretcher
New England, ca. 1740-1760
Walnut
H. 46 3/4" (118.7 cm); W. 34 1/4" (87 cm);
D. 24" (60.9 cm)
Private collection

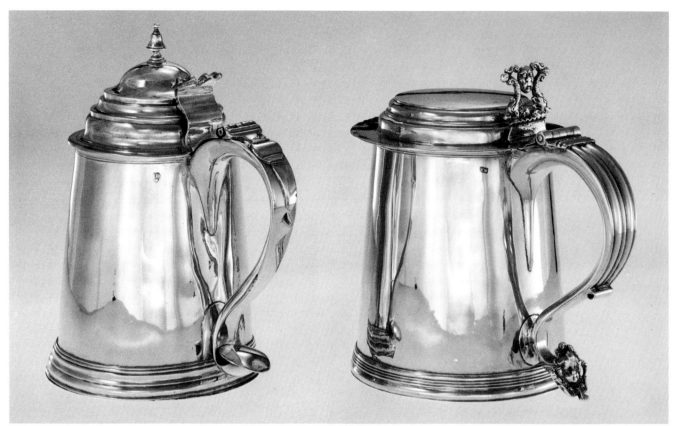

The Dummer tankard (36) illustrates a mistake commonly made by early restorers: the replacement of missing parts of one piece with parts of a later style from another object. Evidences of repair indicate that this tankard has been damaged and restored, perhaps several times. Since all of the parts of the tankard have the appearance of old silver it seems probable that it was restored with parts from another eighteenth-century piece which may also have been in the possession of its owner. The tankard (37) by Edward Webb exhibits the characteristics of an early piece but the tankard by Jeremiah Dummer combines elements of two styles. New England tankards of the seventeenth century have wide proportions and stepped flat covers. By the middle of the eighteenth century tankards had become taller and more tapered with high domed covers and s-curved handles (25). Although the body of the Dummer piece (which bears his mark) has the proportions of a tankard made about 1715 and is embellished with engraving in a seventeenth-century style, comparison with other examples (25 and 37) shows that the cover and thumbpiece conform more closely to the style of 1750, and that the handle has been altered.[1] Solder marks inside the body and on the handle indicate that the handle was repaired and refastened, if not replaced. The inner rim of the cover was changed so it would fit this body, and the stepped moldings, which probably had cracked at the thinnest places, were repaired. *BMW*

1. Buhler and Hood, *American Silver*, no. 18, no. 43.

36
Silver tankard with replaced cover and thumbpiece *1944.24*
Jeremiah Dummer (1645-1718)
Boston, ca. 1700-1715
H. 7 9/16" (19.2 cm); Diam. lip 3 15/16" (10 cm);
Diam. base 5 1/16" (12.9 cm); WT. 23 oz, 10 dwt (729 gm)
Yale University Art Gallery;
gift of Francis B. Trowbridge

37
Silver tankard *1930.1140*
Edward Webb (1666-1718)
Boston, ca. 1690-1710
H. 7" (17.8 cm); Diam. lip 4 3/8" (11.1 cm);
Diam. base 5 3/16" (13.2 cm); WT. 25 oz, 11 dwt (792 gm)
Yale University Art Gallery;
Mabel Brady Garvan Collection

38
Silver tankard (not illustrated) *1930.1063*
Peter Van Dyck (1684-1751)
New York, ca. 1740-1750
H. 7 1/2" (19 cm); Diam. lip 4 7/8" (12.4 cm);
Diam. base 5 13/16" (14.8 cm); WT. 39 oz, 12 dwt (1227 gm)
Yale University Art Gallery;
Mabel Brady Garvan Collection

Through a process called x-ray fluorescence spectrometry scientists are now able to measure the percentage of various atomic elements present in silver alloy, and have determined that old silver contains larger amounts of gold and lead than modern silver. Since the early nineteenth century refining methods have improved, with the result that the amounts of gold and lead in silver alloy have steadily decreased, becoming almost negligible in the twentieth century. This difference makes it possible to identify old and new silver with some accuracy.[1] When this tankard (38) was recently analyzed by this process the tests revealed that a part of its body contains twentieth-century silver. This evidence confirmed the supposition that the tankard once had a spout which was removed about 1930, and that the resulting hole had been filled with modern silver. The restorer of the tankard then chose to hide the patch by machine polishing the entire piece. This not only severely scratched it, but altered the tankard's color and removed most of the surface ripples which are characteristic of handcrafted silver.[2] A contrasting philosophy guided the restoration of the tankard by Edward Webb (37) which also had a spout at one time, and had been engraved in several places, probably in the 1840s. When the piece was restored in the late 1920s no attempt was made to conceal the spout patch and filled-in engraving. *BMW*

1. Victor F. Hanson, "The Curator's Dream Instrument," in William J. Young, ed., *Application of Science in Examination of Works of Art* (Boston, 1973), pp. 18-30.
2. Buhler and Hood, *American Silver,* no. 596.

39
John Norman (1748-1817)
Apotheosis of General Washington
Etching, ca. 1800-1810
H. 5 1/2" (14 cm); W. 3 3/8" (8.5 cm)
Study Collection,
The Henry Francis du Pont Winterthur Museum

John Norman, an architect, portrait engraver and book illustrator, is credited with making the first engraved portrait of Washington in 1779.[1] He followed the trend to deify the General after his death, as shown in this etching. Washington's medallion encloses thirteen stars and is flanked by allegories of Fame blowing her trumpet, and Justice holding her scales and sword.

The etching is genuine, but it has been subjected to repairs. The print was trimmed to the image, once a common practice among collectors. The plate marks and the etched signature "J. Norman sc." were cut off. During the first quarter of the twentieth century, books on American print collecting emphasized the importance of plate marks, and it is possible that these attempts at repair were made then.[2]

To make the etching appear whole again, someone carefully glued a large border of laid paper similar to its own around it. Norman's signature and a completely new platemark were added. Because the glued pieces overlap, the addition of the new border can be seen when the paper is held up to the light. *DS*

1. Carl W. Dreppard, *Early American Prints* (New York, 1930), p. 51.
2. Of principal importance was the Grolier Club's publication in 1904 of its *Catalogue of Engraved Portraits of Washington,* by Charles Henry Hart. Signatures, inscriptions and the precise distance from plate mark to image margin were emphasized. In 1929, Harry T. Peters in his checklist of Currier and Ives prints explicitly warned readers not to cut prints down to the image (Peters, *Currier and Ives,* 1: 182).

Reuben Moulthrop (1763-1814) *1934.160*
Mr. Samuel Bishop
Oil on canvas, 18th century
H. 34 1/8" (88.6 cm); W. 29 3/4" (75.6 cm)
Yale University Art Gallery;
gift of Judge and Mrs. Albert McClellan Mathewson,
L.L.B. 1884, L.L.M. 1891

40a
Photograph of *Mr. Samuel Bishop* (see p. 34)
prior to recent restoration, 1974

Periodic restorations are not uncommon in the lives of works of art which have survived for many years. By 1934, when the first recorded restoration of the Moulthrop took place, the original cloth support was decaying. The painting was removed from its rigid wood strainer and relined with new canvas. Placed upon a new moveable stretcher, the painting was cleaned before losses to the surface were filled and inpainted, and new varnish was added.[1]

Forty years later that thick coat of varnish saved the portrait from very serious damage when water mixed with a white substance—possibly lime—dripped across the surface as the painting hung in a Yale dining hall (40a).[2] During the 1974 restoration by Morton C. Bradley, Jr. which followed this accident, the painting was relined with the additional backing of a thin aluminum sheet. Luckily, the white substance had not penetrated the varnish added by the restorer in 1934. Both were removed in the cleaning process. Once again the surface was inpainted and revarnished.[3]

This sequence of events illustrates not only the vagaries of chance which may bring a painting back to the restorer's studio, but also a cardinal rule practiced in most modern studios: any treatment undertaken by one restorer should be reversible by the next. In this case, it was extremely fortunate that when the 1934 layer of varnish was removed, the 1974 white streak went with it, and the portrait regained its former appearance. *DPC*

1. The 1934 restoration report is on file in the object folder at the Yale University Art Gallery.
2. Memorandum from Fernande E. Ross, Curator of the Intra-University Loan Collection, to Homer Babbidge, 31 March 1975, object folder, Yale University Art Gallery.
3. Condition report, February 1975, object folder, Yale University Art Gallery.

These two paintings of similar subjects by the same hand executed at approximately the same time offer strikingly different appearances to the viewer. The contrast lies in the impact of Abbey's rich coloring with or without a patina of dirt and aged varnish. *Come hither gracious sovereign* (41) has been recently cleaned. Its new colorless varnish lets Abbey's vibrant reds, rich browns and blacks, and shimmering whites and silvers be seen as the artist intended. *The Death of Hotspur* (42) looks dull, dark and flat in comparison. This is especially noticeable in the deep reds which take on an acrid yellowish tinge and in the dingy grey blobs of impasto which really should read as scintillating white highlights on the armor.

The Death of Hotspur is actually in good general condition. The paint surface is not marred by extensive cracking, cupping, or flaking. Were it to be chosen for conservation, the only difficulty would lie in cleaning the areas where the artist has applied paint heavily, building up surface texture, as in the fallen horse in the foreground. Similar areas in *Come hither gracious sovereign,* in the king's crown and in the gold pattern on his shoulder, were somewhat flattened in cleaning. Scientific conservation techniques have reached high sophistication, yet lack of a simple cleaning can alter a painting's impact entirely. *DPC*

41
Edwin Austin Abbey (1852-1911) *1937.1187*
Come hither gracious sovereign — view this body, Henry VI,
Part II (3:2) (not illustrated)
Oil on panel, ca. 1905-1906
H. 22" (55.9 cm); W. 17 1/2" (44.5 cm)
Yale University Art Gallery;
Edwin Austin Abbey Memorial Collection

42
Edwin Austin Abbey (1852-1911) *1937.1174*
The Death of Hotspur, King Henry IV,
Part I (5:4) (not illustrated)
Oil on panel, ca. 1904-1905
H. 24" (61 cm); W. 36 1/2" (92.7 cm)
Yale University Art Gallery;
Edwin Austin Abbey Memorial Collection

For many years John Quidor's dramatic interpretation of the climactic episode in Washington Irving's "Legend of Sleepy Hollow" contained the forms of Ichabod and his horrible pursuer (43a). In 1970, during restoration, the conservator removed the first layer of varnish and discovered that the painted area including the "Headless Horseman" was only a thinly-applied, comparatively recent layer of paint. This fact, along with the awkward placement of the Horseman in the painting and its lack of definition, led the conservator and curators to conclude that the Horseman was not original to the work. Consequently, the Horseman was removed in the 1970 restoration (43).

The 1828 National Academy of Design Exhibition Record lists the title of the work as *Ichabod Crane Flying From the Headless Horseman* rather than *Ichabod Crane Pursued by the Headless Horseman*, the title attached to the work after 1900. The term "flying from" does not unequivocally imply that the Headless Horseman is seen in the act of pursuit; the painting could depict Ichabod alone in the act of flight. Perhaps the Horseman was added to present a more literal representation of the climax of Irving's story. *HK*

43
John Quidor (1801-1881) *1948.68*
Ichabod Crane Flying From the Headless Horseman
Oil on canvas, ca. 1828
H. 22 5/8" (57.5 cm); W. 30 1/16" (76.4 cm)
Yale University Art Gallery;
Mabel Brady Garvan Collection

43a
Photograph of Quidor, *Ichabod Crane,*
prior to restoration in 1970

61

Fakes

A work of art becomes a fake when its maker or a subsequent owner offers it as something it is not with the intention of deceiving a buyer or audience. Any of the works in the other categories of this exhibition — misattributions, alterations, restorations, revivals, or reproductions — could become fakes if presented dishonestly. Eventually most fakes are detected because their makers can never fully transcend their own period. For example, a fake piece of Chippendale furniture made in the 1930s may pass as genuine for a few (or many) years, but usually the passage of time reveals idiosyncracies in its construction or design which indicate that it was not made in the eighteenth century.

Faking works of art for profit is an activity that is closely tied to the art market. As the artistic value of objects is recognized and appreciated, the monetary value also increases. Forgery seems to operate in conjunction with the law of supply and demand. When objects are sought after and purchased by private collectors and museums, the number remaining on the open market diminishes. The increased demand invites forgery.

Whereas forgery has been going on in Europe for centuries, in America it is a relatively recent phenomenon. When Americans began to develop an awareness of their heritage during the late nineteenth century, a new interest in portraits by John Trumbull and other eighteenth-century artists was awakened. Fakers catered to this new interest by producing spurious portraits of colonial Americans (70).[1] In the 1920s Frank Bayley, a Boston dealer, took advantage of this situation by selling many English portraits as paintings done by colonial artists such as Badger, Blackburn, Copley, Feke and Smibert.[2] In 1929 Bayley boldly published a book illustrating the work of these five artists in which he included both spurious and genuine paintings. He declared audaciously that he was guided by

the desire to not only further the growing interest in early American portraiture, but to assist in the identification of many portraits whose authorship is not known, or wrongly attributed.[3]

We know today that his motivation was actually quite different.

Works of art can be faked in many ways. Perhaps the easiest method of faking is deliberate misattribution, presenting a work that is known to be one thing as something else. This involves little work for the faker, who has only to declare that a work is by a different or better-known artist, that an object was produced in a place other than is actually the case, or that a reproduction is an orginal. Pieces that were not made as deceptions may become so by the act of an unscrupulous person. To lend credence to deliberate misattributions, falsified documentation, such as supporting letters or family histories, may be appended to the work. The existence of "something in writing" will convince many people of the accuracy of the claims.

Another way of faking an object is to falsify a signature or mark as a means of upgrading the object. The faker will usually use a genuine object from a given period as the basis for his work, adding a signature or mark of the same period. For example, a faker might add a Paul Revere mark to a rococo-style piece of silver (50). When the painter William Harnett (1848-1892) was rediscovered in the 1930s and his work became quite popular, Alfred Frankenstein observed that Harnett seemed to have both a "hard" and "soft" style. In 1947 after a great deal of looking, Frankenstein ascertained that the "soft" style was actually the work of another artist, John Peto (1854-1907), whose signature had been painted over and replaced with the forged name of the more highly-regarded Harnett.[4]

The composition or parts of a work of art may also be altered. An object can have elements added, removed, or restored in order to make a more "perfect" piece, one which will be considered rarer and more valuable. Portraits with solid backgrounds may be supplied with a landscape scene, engraving may be added to silver, furniture may be given inlay, carving or veneer. The faker can create an oil by painting over a lithograph (78), or can change a mass-produced version of a print into an "original" by adding plate marks or edition inscriptions. A restrike of a print that is produced without the artist's authorization, often after his death, can be presented as one that was supervised by the artist or his delegated representative.

A more drastic form of alteration is illustrated by "married" pieces, objects which are created from parts of old ones. The faker may take two or more real pieces or parts of objects and join or "marry" them together so that it appears that the new work is completely authentic. This type of deception can be difficult to detect, since the individual parts are genuine. In furniture, a slant-front desk and a bookcase can be brought together to make a new desk and bookcase (45). Because of the standardization of sizes produced in a "piece-work" shop system, such marriages of the tops and bottoms from different pieces of furniture are relatively easy.[5]

Another way of using existing objects as models for fakes is to create a pastiche taking elements from several works, for example, copying the figure from one painting and the background from another. Discovery of this type of fraud occurs when it is noticed that the juxtaposition of elements or parts is peculiar and unlike the careful composition or arrangement normally found in the work of an artist, maker, or school. To escape easy detection, the faker may avoid using the exact elements of an artist, and instead work in "the style of" an artist or period. This type of forgery is more readily noticed with the passage of time. What looks right to contemporary eyes will appear odd to a later generation with a different understanding and view of an artistic period.

A faker who has artistic talent may create a completely new and fradulent work rather than alter an existing one. The clever forger will attempt to foil an expert by using old materials or methods that seem to indicate age. He will use authentic old materials— he may paint on old canvases, draw on paper of the period, or use old wood to create pieces of furniture. Sophisticated forgers know that modern paint can be detected through scientific analysis, and therefore mix their pigments so that their paint mixture resembles that of the artist they are faking.

Although it is easier, it is not always as profitable to fake contemporary works of art. Paintings and prints are usually the only kinds of contemporary art forged today. Because mass-produced items, such as the Cesca chair "knock-off" (100) can so closely approximate the "real" object for a fraction of its cost, it is not worthwhile to fake the original.

Our culture imbues the art forger with the mystique reserved for the international jewel thief. The faker is the popular subject of films and books. Generally, we seem to be more fascinated with the faker's exploits than condemnatory of his attempted fraud. The laws of the United States are such that it is difficult to prosecute the faker, perhaps an indication of society's reluctance to brand this activity as a criminal act. As long as faking works of art remains a profitable and fairly safe business, this activity will continue. Unfortunately, only time will reveal to the eye of the beholder the fake works of art still masquerading as "real" objects in museums, private collections and dealers' hands.

Judith Bernstein

Notes

1. Theodore Sizer, "Works of Col. John Trumbull," *The Art Bulletin* 38, no. 1 (March 1956): xii-xiii.
2. Albert Ten Eyck Gardner and Stuart P. Feld, *American Paintings, A Catalogue of the Collection of the Metropolitan Museum of Art. I. Painters born by 1815* (New York, 1965), p. 284.
3. Frank Bayley, *Five Colonial Artists of New England* (Boston, 1929), p. v.
4. Alfred Frankenstein, *After the Hunt*, rev. ed. (Berkeley, California, 1969), pp. 3-24.
5. This assertion is borne out by the study of English and American furniture "price books."

Until fairly recently this card table, long thought to have been made in Baltimore, Maryland, in the last decades of the eighteenth century, was considered one of the great masterpieces of American furniture. It was exhibited as such in the Baltimore Furniture Show of 1947.[1] Careful study has since identified idiosyncracies in its construction, proportions and inlaid decoration which indicate that it is a very skillful fake.[2] The frame of the table is probably English, but the veneer and inlay are new. The legs are not original to the frame. Instead of continuing as one piece of wood to which the frame is mortised and tenoned, they are attached with modern dowels to the underside of the frame. The shadow mark visible on the underside of the tabletop differs from the mark which the present frame would have caused, indicating that the frame is not original to the table. Moreover, the inlay was made to suit the taste of the early twentieth century: the griffin, though based on a related pattern in plate 56 of Thomas Sheraton's *The Cabinet-Maker and Upholsterer's Drawing-Book* (London, 1793) is unknown in American furniture inlay, and the bellflowers on the legs are exaggerated in size. *FJP*

1. *Baltimore Furniture: The Work of Baltimore and Annapolis Cabinetmakers from 1760 to 1810* (Baltimore, 1947), pp. 20, 43.
2. John T. Kirk, *Early American Furniture* (New York, 1970), p. 177

44
Card table *1930.2010*
English and American, 1780-1800, 20th century
Mahogany; mahogany and satinwood (?) veneers; oak and pine
H. 29 1/2" (74.9 cm); W. 36 1/2" (92.7 cm);
D. 35 1/2" (90 cm)
Study Collection, Yale University Art Gallery

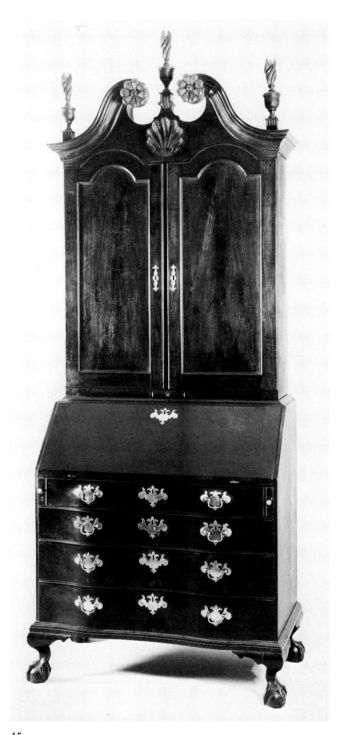

The combination of two (or more) genuine pieces of furniture which were not joined together originally is known as a "marriage." In this example, a Massachusetts reverse-serpentine front desk has been united with a Pennsylvania bookcase.[1] The unusual combination of forms from two different regions immediately causes suspicion about the authenticity of this piece, and closer examination reveals further evidence that the two sections were not originally joined together. The bookcase is made of walnut, the desk of mahogany. When the two pieces were brought together they were refinished and an attempt was made to match the colors of the two sections. At the same time, a new mid-molding was applied and, to increase the illusion of unity, a shell was carved in the interior door of the desk to match the shell in the bonnet.[2] *KS*

1. For an example of a Massachusetts slant front desk related to the base of this piece, see Joseph Downs, *American Furniture, Queen Anne and Chippendale* (New York, 1952), no. 217. For a Pennsylvania desk and bookcase related to the top of this piece (although made of maple rather than walnut), see Downs, no. 233.
2. John T. Kirk, *Early American Furniture* (New York, 1970), p. 181.

45
Desk and bookcase *1950.699*
Eastern Massachusetts and Pennsylvania, ca. 1760-1790
Mahogany and walnut; white pine, tulip
H. 107" (271.8 cm); W. 43 1/8" (109.5 cm);
D. 23" (58.4 cm)
Study Collection, Yale University Art Gallery

The first wainscot chair (46) in this comparison was made in the early twentieth century and exemplifies a common phenomenon of objects made in imitation of earlier forms—a reduction in scale of their parts and ornament. Unlike the authentic wainscot chair (47) which is characterized by massive elements, four-square proportions, and heavy and robust turnings, the imitation wainscot chair has thin individual members, taller and narrower proportions, and spindly turnings.[1]

In addition to these formal differences, the latter example exhibits other features which suggest the hand of a faker. To give this chair the aura of age, pieces of wood have been let in to the stiles where the arms and seat rails join them, stress points where one might expect to find repairs on a seventeenth-century chair. Moreover, the surface has been smeared with a stain; the resulting ashen cast is frequently found on wood that has been doctored to simulate the look of age. *BZW*

1. Homer Eaton Keyes, "Dennis or a Lesser Light," in Robert F. Trent, ed., *Pilgrim Century Furniture* (New York, 1976), pp. 82-83.

46
Wainscot chair *1930.2418*
American, early 20th century
Oak; cedar, walnut
H. 41 9/16" (105 cm); W. 23 13/16" (60.5 cm);
D. 14 1/2" (36.9 cm)
Study Collection, Yale University Art Gallery

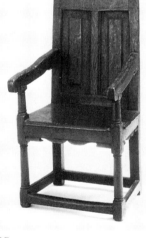

47
Wainscot chair *1841.1*
Connecticut, 1640-1660
White oak
H. 41 1/4" (104.8 cm); W. 23" (58.4 cm);
D. 13 7/8" (35.2 cm)
Yale University Art Gallery;
gift of the Reverend John E. Bray

Frequently fakers, instead of constructing whole new pieces, embellish old ones to increase their value. In this example (48) the embellishment resulted in the creation of a chair which incorporates features of two styles. For many years this chair was regarded as being in an "intermediate" style.[1] Although some difference of opinion exists over how much of this chair was rebuilt, it is probable that it was originally a Philadelphia Queen Anne chair with a solid splat and curved crest rail. The faker carved a new splat in imitation of a design which is often found on Philadelphia Chippendale style chairs (49). He also embellished the upper edges of the seat rails and front faces of the stiles with ornamental carving. The large shell below the seat was carved from a separate block of wood and inserted into the center of the front seat rail and the new Chippendale-style crest rail was attached to the back posts with wooden braces and modern screws. One particularly peculiar feature of the crest rail carving is that the tassels do not continue onto the splat and are therefore not integrated into the splat design as is usual on eighteenth-century chairs. To obscure these modifications the whole chair was finished with a thick, dark brown, varnish.[2] *BMW*

1. Joseph Downs, *American Furniture, Queen Anne and Chippendale Periods* (New York, 1952), no. 119.
2. This analysis is based on notes by Charles Hummel, Nancy Richards, Benno Forman, and Nancy Evans in the Registrar's files of The Henry Francis du Pont Winterthur Museum, and the chair was examined with the assistance of Nancy Richards, Associate Curator.

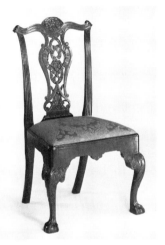

49
Side chair *1930.2501*
Philadelphia, ca. 1760-1780
Mahogany; tulip
H. 40" (101.6 cm); W. 21 5/8" (54.9 cm);
D. 17 7/16" (44.3 cm)
Yale University Art Gallery;
Mabel Brady Garvan Collection

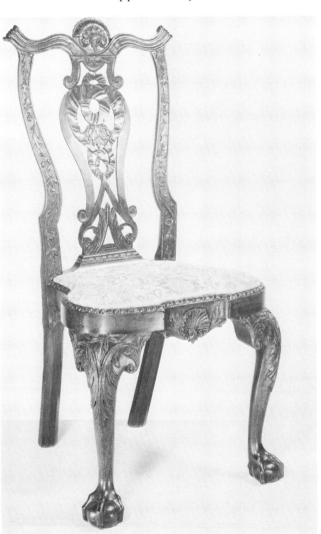

48
Side chair with added carving
Philadelphia, ca. 1750-1760, 1880-1925
Mahogany
H. 42" (106.7 cm); W. 20 1/2" (52 cm);
D. 20 3/4" (52.7 cm)
Study Collection,
The Henry Francis du Pont Winterthur Museum

This creampot (50) represents a case in which a damaged piece of little value was repaired and made desirable through the addition of a false mark. An eighth of an inch of silver has been added to the height of the rim and the pouring lip has been restored. At the time these changes were made they were probably not easily seen; time and polishing have uncovered the intended deception. Comparison of its mark (50a) with an authentic one (51) is revealing. Two things about the false mark immediately arouse suspicion, the lack of accumulated dirt and tarnish around the raised letters, and the shallow relief of the mark. In addition, the edges of the letters in the false touch are irregular, a characteristic often encountered in forged marks. When seen under magnification it appears that the "P. Revere" mark has been stamped over another mark. The uneven surface and the numerous short deep scratches on the bottom of the creampot suggest that English hallmarks may have been removed and that the indentations they left were camouflaged with engraving and artificial signs of wear. *BMW*

50a
Fake mark on 50

51
Genuine mark on a silver salt *1930.1393*
Paul Revere (1735-1818)
Boston, ca. 1760-1770
H. 1 5/8" (4.1 cm); Diam. 2 9/16" (6.5 cm);
WT. 2 oz, 9 dwt (76 gm)
Yale University Art Gallery;
Mabel Brady Garvan Collection

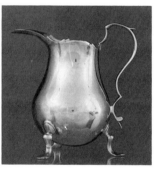

50
Silver creampot *1968.86.1*
Fake mark of Paul Revere II (Boston, 1735-1818)
Probably American, ca. 1760-1770
H. 3 3/4" (9.5 cm); WT. 3 oz, 17 dwt (119.4 gm)
Study Collection, Yale University Art Gallery

52
Silver bowl *1930.1250*
Fake mark of Paul Revere (Boston, 1735-1818)
Probably made in the early 20th century
H. 3 7/8" (9.8 cm); Diam. lip 9 5/16" (23.7 cm);
Diam. base 4 1/4" (10.8 cm); WT. 34 oz, 8 dwt (1066 gm)
Study Collection, Yale University Art Gallery

53
Silver bowl (not illustrated) *1953.10.3*
John Heath (Freeman, 1761)
New York, ca. 1760
H. 4 1/4" (10.8 cm); Diam. lip 10 1/8" (25.7 cm);
Diam. base 5 1/4" (13.3 cm); WT. 29 oz, 11 dwt (916 gm)
Yale University Art Gallery;
John Marshall Phillips Collection

Although John Marshall Phillips accepted this bowl (52) as genuine, Kathryn Buhler and Graham Hood determined that the Revere mark was clearly a forgery, and that the bowl itself, if authentic, was probably made in New York rather than in Boston.[1] Recently it has been decided that the entire piece is of modern manufacture.[2]

Several factors contribute to this conclusion: (1) the bowl lacks the hammer marks found on handwrought silver and the faker has attempted to simulate this surface effect by pitting the inside of the bowl with a sharp instrument; (2) the bowl is extremely heavy and the rim is very blunt and shows no signs of wear, especially when compared to a genuine eighteenth-century bowl (53) which has a delicate, almost sharp edge characteristic of old silver;[3] (3) the gouges in the bright-cut engraving are unusually small and close together, hence the overall design lacks the free sweeping quality of American neo-classical engraving; (4) the foot is unlike molded bases found on American silver—it resembles the type of foot encountered on oriental ceramic bowls, clearly the model which the faker had in mind. *BMW*

1. Buhler and Hood, *American Silver*, no. 249.
2. This became evident to Charles F. Montgomery when students in his undergraduate course, who had never seen the bowl before, began to question its authenticity and point out its inconsistencies.
3. Buhler and Hood, *American Silver*, no. 724.

In the 1920s a large number of fake silver objects were made and sold as family silver which had belonged to several prominent colonial Philadelphians. While studying the silver made by Joseph Richardson, Sr., Martha Gandy Fales and Richard N. Williams II encountered several fakes which bore the same false "IR" mark and exhibited features inconsistent with eighteenth-century methods of fabrication. This particular tankard aroused their suspicions for several reasons. The heart-shaped handle terminal is not characteristic of Richardson's work; he nearly always used a shield-shaped terminal such as the one on the Yale example (55).[1] The dent on the handle (which should occur where it comes in contact with the thumbpiece) does not correspond to the point where the present thumbpiece hits the handle, indicating that the two parts have not always been together. Although moldings were customarily attached to the sides of a tankard, the base molding of the fake (54) does not overlap the body of the tankard at all.[2]

X-ray fluorescence spectrometry tests show that the tankard contains both old and new silver. This evidence suggests that the tankard was constructed from various surviving fragments and new pieces which the faker skillfully fitted together.[3] He then scratched the surface of the tankard to conceal his use of modern silver for parts of the body. *BMW*

1. Buhler and Hood, *American Silver*, no. 832.
2. Martha Gandy Fales, "Some Forged Richardson Silver," *Antiques* 79, no. 5 (May 1961): 466-469.
3. Victor F. Hanson, "The Curator's Dream Instrument," pp. 18-30.

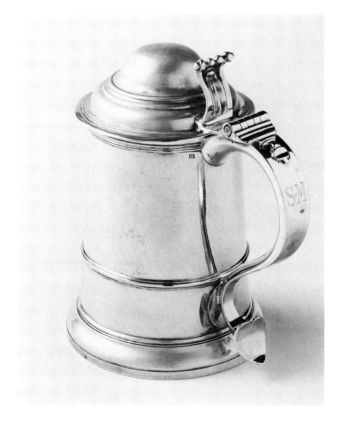

54
Silver tankard
Fake mark of Joseph Richardson, Sr.
(Philadelphia, 1711-1784)
Probably made in or near Philadelphia, ca. 1925-1945
H. 7 3/8" (18.8 cm); W. 7 3/4" (19.2 cm);
D. 5 3/16" (13.2 cm)
Study Collection,
The Henry Francis du Pont Winterthur Museum

55
Silver tankard (not illustrated) *1930.1232*
Joseph Richardson, Sr. (1711-1784)
Philadelphia, ca. 1740-1750
H. 7 1/16" (17.9 cm); Diam. lip 4 3/8" (11.1 cm);
Diam. base 5 1/2" (14 cm); WT. 28 oz, 19 dwt (898 gm)
Yale University Art Gallery;
Mabel Brady Garvan Collection

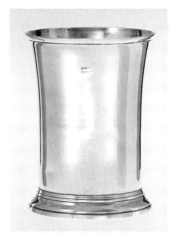

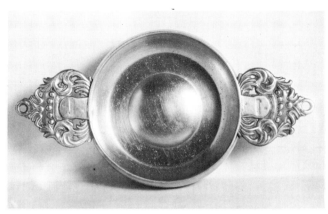

56
Silver beaker *1932.82*
Fake mark of John Burt (Boston, 1691-1745)
English or Irish (hallmarks erased), ca. 1700-1710
H. 4 7/8" (12.4 cm); Diam. lip 3 11/16" (9.3 cm);
Diam. base 3 9/16" (9 cm); WT. 10 oz, (310 gm)
Study Collection, Yale University Art Gallery

57
Pewter porringer *1930.751*
Fake mark of T. D. and S. Boardman (w. 1805-1850)
Probably made in the 20th century
H. 1 11/16" (4.3 cm); Diam. rim 5" (12.7 cm)
Study Collection, Yale University Art Gallery

58
Pewter porringer (not illustrated) *1931.173*
Thomas D. Boardman (w. 1805-1820)
Hartford, Connecticut, 1805-1820
H. 1 13/16" (4.6 cm); Diam. rim 4 7/8" (12.4 cm)
Yale University Art Gallery;
Mabel Brady Garvan Collection

As early as 1938 John Marshall Phillips determined that this beaker (56) was an altered English piece with a fake American mark.[1] American silver usually has a maker's mark alone but British silver customarily bears several hallmarks: a maker's mark, a standard mark, an assay office mark, and a date letter. Four indentations appear on the bottom of this beaker which suggest that it once had English hallmarks which were erased. In addition the beaker is taller and more tapered than Boston examples and has a widely flaring base molding not found on colonial pieces of this form.

The mark on the side of the beaker just below the rim differs significantly from the authentic mark of John Burt (25). In the genuine touch the "J" dips below the line of the other letters in "JOHN," a feature which is missing in the forgery. There is also a significant difference in the shape and size of the letters. In the forgery they are flatter and broader and there is little variation in the thickness of the lines. Particularly noticeable in the "B", these differences are also apparent in the other letters. *BMW*

1. John Marshall Phillips, "Faked American Silver," in Ruth Webb Lee, *Antique Fakes and Reproductions* (Wellesley Hills, Massachusetts, 1950), pp. 244-252, pl. 135, 136.

Few crown-handled porringers by Thomas D. and Sherman Boardman survive today, and Boardman porringers with two crown handles are unknown.[1] This example (57) is a fake. A close comparison of the fake with a real Boardman crown-handled porringer (58) reveals certain differences. The single-handed porringer was produced in the traditional method. The bowl was cast and then smoothed on a lathe, which produced a sturdy metal with a soft sheen. The fake was fabricated by spinning flat sheet metal which gives the surface a hard, taut, skin-like metallic quality. The real Boardman handle is well cast and finished in contrast to the ill-defined detail on the handles of the fake. The two handles of the fake share identical signs of wear, especially around the mark, and were probably cast from the same plaster of paris mold made from the impression of a real Boardman handle. The method of attaching the handles also distinguishes the real from the impostor. The handle on the old porringer was cast directly onto the bowl in the traditional manner, leaving a linen mark on the inner surface.[2] This characteristic is usually found on authentic porringers. The two-handled porringer lacks this feature since the handles have been soldered on, a method used in the twentieth century. *ESC*

1. Charles F. Montgomery, *A History of American Pewter* (New York, 1973), p. 150
2. Montgomery, *American Pewter*, p. 37.

59
Pewter inkwell *1931.296*
Bottom made from a pewter plate
Plate bears the marks of Thomas Danforth II (1731-1782)
Middletown, Connecticut, 1755-1782
H. 2 1/4" (5.7 cm); Diam. 4 1/4" (10.8 cm)
Study Collection, Yale University Art Gallery

Inkwells were among the more unconventional objects made by early American pewterers. Few genuine examples survive, hence the rarity of the form invites fakery. Although this example is stamped on the bottom with the marks of Thomas Danforth II, it exhibits certain features which indicate that it is a fake. Examination of this example reveals that it was not fabricated in the traditional way. The faker has made the bottom by taking part of a Danforth plate and soldering a drum to it. This drum is nineteenth-century in style, and therefore is inconsistent with the eighteenth-century style that one would expect to find on genuine pewter by Thomas Danforth II. The faker has attempted to make a plate, a common pewter form, into a more valuable and saleable object. Knowledge of eighteenth-century style and methods of fabrication alerts the connoisseur to the fraudulence of this object. *ESC*

60
Pewter inkstand
Fake mark of Thomas Badger (1764-1826)
Probably Germany, 1920-1950
H. 2 7/8" (7.3 cm); W. 9 1/2" (24.1 cm);
D. 5 9/16" (14.1 cm)
Study Collection,
The Henry Francis du Pont Winterthur Museum

60a
Mark on the pewter inkstand (60)

61
Steel die (see p. 42)
Fake mark of Thomas Badger (1764-1826)
American, 1920-1950
L. 2 1/2" (6.4 cm); W. 7/8" (2.2 cm);
D. 1 1/8" (2.9 cm)
Study Collection,
The Henry Francis du Pont Winterthur Museum

62
Genuine mark on a pewter dish *1942.133*
Thomas Badger (1764-1826)
Boston, 1787-1815
Diam. 14 7/8" (37.8 cm)
Yale University Art Gallery;
gift of Mrs. James C. Greenway

In the 1930s a New York department store sold new Continental pewter objects marked with crude reproduction marks of the American pewterers Parks Boyd, William Will, Thomas Badger, and others.[1] Among the forms so stamped were porringers, plates, cups, and inkstands (60).[2] The rectangular platter, flattened ball feet, and concave baluster inkwell and sander are the Germanic features of this inkwell.[3] Compared with a real Badger mark (62) its modern mark (60a) lacks depth, its lettering is thick and flat and without serifs, and its lines are crude. The anomaly of having Germanic forms marked with crude reproductions of American pewterers' marks should preclude any possibility of identifying these pieces as authentic examples of early American pewter.

The mark produced by a different modern die (61) is harder to discern as a counterfeit.[4] It differs only in its larger size, lack of detail in the feathers of the eagle's wings, and the addition of hatched columns on the lower sides. If this mark were stamped on unmarked authentic American pieces it would be hard to detect as modern. *ESC*

1. Mallory, "Fakes and Falsies," p. 9.
2. Laughlin, 2:124.
3. Mallory, "Fakes and Falsies," pp. 96, 97.
4. Laughlin, 2: plate LXXVIII, figures 684, 309a.

There are differences between these andirons which mark one pair as authentic eighteenth-century examples (64) and the other pair as fakes (63). The manner in which modern examples are constructed varies from the way andirons were made prior to 1820. Before that time the legs were usually cast as solid pieces, but the plinth above the legs, the central shaft, and the upper shaft, including the finial and faceted square below it, were cast as separate pieces in halves which were braised together. Usually in the case of American andirons made before 1790 these separately cast pieces were held in place by an iron rod which passes from the legs through the hollow center of the andiron and was peened over the tip of the finial. In the modern examples (63), and most brass andirons made after 1790, the finials are screwed onto the central shaft. The fakes also lack the small plinth below the faceted square which is found on the originals. This plinth was an integral part of the design of eighteenth-century andirons and would not normally have been omitted on an authentic example. *FJP*

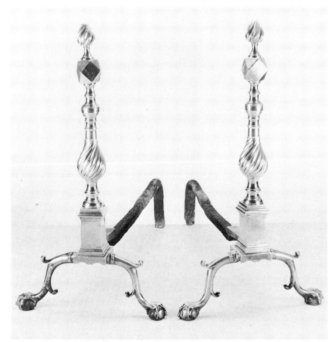

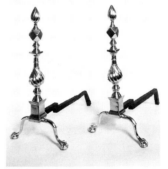

63
Pair of brass andirons
American, probably 1925-1950
H. 25 1/2" (64.8 cm); W. 13 1/2" (34.3 cm);
D. 25" (63.5 cm)
Study Collection,
The Henry Francis du Pont Winterthur Museum

64
Pair of brass andirons
American, 1760-1780
H. 24 7/8" (63.2 cm); W. 12 3/4" (32.4 cm);
D. 21 1/4" (54 cm)
Yale University Art Gallery;
bequest of Olive Louise Dann

1962.31.58

Reawakening Colonial Life

ics, textiles and paintings—many bor-
rowed from collectors and institutions
—to show the pervasiveness of certain
stylistic motifs, and architectural
themes in the decorative arts.

...period.
...to decipher than outrig...
...axes. For example, 18th-century silv...
tankards do look strange when th...
sprout spouts and become pitchers—
can be seen in one original and ...
altered silver vessel. And a secret...
assembled from two 18th-century pa...
—a slant-front Massachusetts d...
base and a Philadelphia bookcase to...
would seem out of whack to the...
noisseur, because the two styles d... Ph...

Although they have been eagerly sought by collectors for many years, very little is known about the tall iron and brass candlestands used and presumably made in America during the seventeenth and eighteenth centuries. Even those examples considered to be of American manufacture (66) can only be given a probable provenance and a general date.

This lack of knowledge, combined with the rarity of the form and their desirability as decorative features in period rooms has created many opportunities for the faker. As early as 1923, Arthur Hayward noted that the scarcity and high price of candlestands was a "great temptation for unscrupulous dealers . . . to counterfeit."[1] Reproductions made by Wallace Nutting and others have been in existence now for over half a century, and further confuse the issue.[2]

Purchased as one of a pair of "New England" eighteenth-century candlestands, the other stand included here (65) is now thought to have been made in New Hampshire during the 1920s. Its lack of wear, and sharp hard edges, atypical flat drip pans (rivetted rather than screwed to the crossarm) and the fact that the candle cups and finial are not cast in halves, are indications of its twentieth-century manufacture.
GWRW

1. Arthur Hayward, *Colonial Lighting* (New York, 1962), pp. 87-88.
2. See Nutting's sales catalogue of *Early American Iron Work* (1919).

65
Candlestand
Probably New Hampshire, 1920-1930
Iron, brass
H. 63" (160 cm); W. 21" (53.3 cm)
Study Collection,
The Henry Francis du Pont Winterthur Museum

66
Candlestand (not illustrated)
Probably Middle Colonies, 18th century
Iron, brass
H. 61" (155 cm); W. 17 1/16" (43.4 cm)
Mr. and Mrs. George Kaufman

Both these pitchers are examples of the type of glass that collectors refer to as the "South Jersey type." This glass is utilitarian in nature, is made without the use of molds, has both tooled and hand applied decoration, and is most often light blue green in color. The tradition was introduced into this country by the German glassblowers of Caspar Wistar's glasshouse in southern New Jersey—the first successful glasshouse in America, founded in 1739 and in operation until 1780.[1] These workmen dispersed after the closing of the factory, disseminating their style, and glass made in their tradition is today referred to as "South Jersey" glass, regardless of where or when it was made. It so happens that both of these pieces were probably made in New Jersey, one (68) in the first half of the nineteenth century, and the other (67) in the twentieth century. Although it is often very difficult to date these pieces, the first pitcher (67) is related to glass made in the Clevinger Brothers glass factory in Clayton, New Jersey, by the regularity of the four swags around the body of the pitcher.[2] In older examples (68) these swags are more numerous and irregular. Moreover, the Clevinger Brothers' pitcher also has a different color than old glass and the wear on its foot is minimal, indicating a recent date of manufacture. *FJP*

1. For more information on Caspar Wistar and the South Jersey tradition see McKearin, *American Glass,* pp. 37-43.
2. This information is contained in the object folder at the Henry Francis du Pont Winterthur Museum.

67
Glass pitcher
Probably Clevinger Brothers Glass Factory
Probably Clayton, New Jersey, ca. 1930
H. 6 1/2" (16.6 cm); W. 6 1/4" (16 cm);
D. 5" (12.8 cm)
Study Collection,
The Henry Francis du Pont Winterthur Museum

68
Glass pitcher (not illustrated) *1930.1501*
Probably New Jersey, 1825-1850
H. 6 7/8" (17.5 cm); W. 6 3/8" (16.3 cm);
D. 4 5/8" (11.8 cm)
Yale University Art Gallery;
Mabel Brady Garvan Collection

The discovery in 1934 of a group of glass vessels with this pattern[1] and a history of ownership in one family in New Jersey, led glass historians to think that glass made in this pattern originated in southeastern Pennsylvania or southern New Jersey, probably between 1815 and 1840. Frederick Mutzer, a German immigrant, or his descendants were thought to have originated the pattern and blown the glass.[2] However, the problem of determining the authenticity of vessels with this pattern was complicated by their reproduction in large numbers during recent decades by Clevinger Brothers, a glass factory in Clayton, New Jersey. The pieces produced by Clevinger Brothers were not necessarily produced as fakes, but have fooled numerous collectors because of their lack of a manufacturer's mark and because they are nearly identical to the "authentic" glass attributed to the Mutzers. Actually, recent study has shown that "Mutzer" glass, the glass upon which Clevinger based its deceivingly close copies, is fake and was probably made between 1920 and 1929 to capitalize on recent interest in glass of this type; its chemical, physical and visual qualities are different from authentic nineteenth-century glass.[3] Clevinger Brothers effectively produced a copy of a fake. *FJP*

1. McKearin, *American Glass*, plate 92.
2. George S. McKearin, "From Family Glass Cupboards," *Antiques* 59, no. 2 (February 1951): 131-133.
3. Dwight P. Lanmon, Robert H. Brill, and George J. Reylly, "Some Blown 'Three-Mold' Suspicions Confirmed," *Journal of Glass Studies* 15 (1973): 160.

69
Glass decanter
Probably Clevinger Brothers
Probably Clayton, New Jersey, ca. 1930-1960
H. 10" (25.4 cm); D. 4 5/8" (11.8 cm)
Study Collection,
The Henry Francis du Pont Winterthur Museum

70
Unknown 1942.276
Adjutant-General Joseph Reed
Ink on paper mounted on cardboard, late 19th century
H. 6 7/8" (17.5 cm); W. 5" (12.7 cm)
Yale University Art Gallery

71
John Trumbull (1756-1843) 1931.66
Captain Blodget
Pencil on paper, late 18th century
H. 4 1/2" (11.4 cm); W. 2 7/8" (7.3 cm)
Yale University Art Gallery;
gift of Mrs. Winchester Bennett

When John Trumbull's skillful portrait-sketch of
Captain Blodget (71) is compared to the heavy-
handed depiction (70) of Adjutant-General Joseph
Reed, it is easy to see why the authenticity of the
latter was questioned when the drawing came on the
art market in the late nineteenth century. Signed
"1786JT" on the front, and "original pen and ink
drawing Adj. Genl Jo.ˢ Reed by John Trumbull" on
the back, the fraudulent drawing was part of a collec-
tion, widely judged to be made up of fakes, offered
for sale in 1894 by Edouard Frossard. The features of
Joseph Reed are poorly drawn with thick and heavy
lines and shadows are achieved through clumsy cross-
hatched strokes. In contrast, Trumbull's portrait of
Captain Blodget is freely rendered through building
up fine lines. The source for the fake drawing was
probably the closely related engraving by J. Sartain of
Charles Willson Peale's portrait of Reed which
appeared as the frontispiece in William Reed's *Life
and Correspondence of Joseph Reed* (1847).
JB and HK

73
John Singer Sargent (1856-1925) *1971.181*
The Salute, Venice
Watercolor over pencil on paper, ca. 1900-1909
H. 20" (50.8 cm); W. 14" (35.6 cm)
Yale University Art Gallery;
Christian A. Zabriskie Fund

72
In the style of John Singer Sargent
Venetian View
Watercolor over pencil on paper, 20th century
H. 14" (35.6 cm); W. 11" (27.9 cm)
Private collection

The creator of this spurious Sargent (72) may well have been familiar with the artist's working methods as described in Donelson F. Hoopes, *Sargent Watercolors* (New York, 1970). The imitator's logical subject was Santa Maria Della Salute, which Sargent often painted (73). Hoopes records Sargent's penchant for contrasting detailed treatment of architecture with simply-drawn surrounding elements. Following this formula, Sargent's imitator reduced the buildings on either side of the Salute to abstract planes, yet their red color draws too much attention, defeating the intended effect.

Few of Sargent's watercolors were created for public display. Often they were inscribed and given as gifts. A penciled notation "to my dear V, John Singer Sargent" embellishes the fake, giving it added credence. "V" alludes to his sister Violet.

Details of the Salute are carefully, if clumsily, borrowed from genuine Sargent watercolors.[1] Left to his own imagination, the faker displays an even less sure hand. The obtrusive foreground boats lack the fluidity of Sargent's brush. Although sketched designs underly Sargent's watercolors, this fake bears extraneous markings and the lines control rather than suggest the composition. Pigment was added in an unspontaneous color-book fashion. An overall sense of tightness combined with flatness of color and heavy-handed opaque white highlights suggest that Sargent never saw this particular view of the Salute. *DPC*

1. For example, *Santa Maria Della Salute* (1904), now in the Brooklyn Museum of Art, and illustrated in Hoopes, plate 3, page 27.

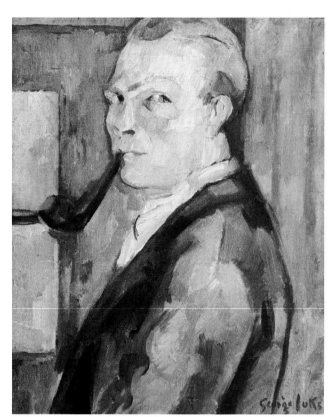

75
George Luks (1867-1933) *1950.123*
Chess Players
Oil on canvas, early 20th century
H. 25 1/8" (63.8 cm); W. 36" (91.4 cm)
Yale University Art Gallery;
gift of Mrs. Francis P. Garvan
for the Mabel Brady Garvan Collection

74
Unknown
The Pipe Smoker
Bearing the fake signature "George Luks"
Oil on canvas, 1920-1950
H. 16 1/4" (41.5 cm); W. 13 1/4" (33.7 cm)
Conservation Center, Institute of Fine Arts,
New York University

George Luks was a prominent member of The Eight, the early twentieth-century group of American realists, whose art depicted the harsh daily reality of city life. He painted individuals with character, in his words, "people with edge."[1] Swift, loose brushstrokes and strong color are typical of his work, as in the painting *Chess Players* (75).

Although *The Pipe Smoker* (74) bears the signature "George Luks" in the lower right corner, and the words "Pipe Smoker of George Luks" on the back of the panel, the work is a fake. The sombre tones and thick brushstrokes are characteristic of Luks, but the cubist-inspired planes of color are not. The painting lacks the impetuous, strong presentation typical of his style. The brushstrokes are mannered, unlike the fluid application of paint usually found in Luks's works.

The Pipe Smoker is one of a group of twenty-five fake paintings by various artists presented as a study collection to New York University in 1963, and now used by the Conservation Center of the Institute of Fine Arts. *HK*

1. Newark Museum, *Catalog of an Exhibition of Works of George Luks* (Newark, 1934), p. 15.

Cottonus Matherus
S. Theologiæ Doctor Regiæ Societatis Londinensis Socius
Ecclesiæ apud Bostonum Nov Anglorum nuper Præpositus.
Ætatis Suæ LXV. MDCCXXVII. P.P elham ad vivum pinxit et Fecit et Exc.

76
After Peter Pelham
Cottonus Matherus
Mezzotint reproduced photographically, 20th century
H. 13 3/8" (34 cm); W. 9 5/8" (24.5 cm)
Study Collection, Yale University Art Gallery

77
Peter Pelham (1697-1751) *1946.9.200*
Cottonus Matherus (not illustrated)
Mezzotint engraving, 1728
H. 13 7/8" (35.3 cm); W. 9 7/8" (25.1 cm)
Yale University Art Gallery;
Mabel Brady Garvan Collection

Peter Pelham's print of Cotton Mather (77) is
distinguished as America's first mezzotint. Most
earlier American portrait prints, such as Thomas
Emme's 1702 line engraving of Increase Mather, and
James Franklin's 1717 woodcut of Hugh Peter, were
book illustrations. In contrast, Pelham's print of
Cotton Mather was sold individually. Engraved the
year of the Boston clergyman's death, the print had a
commemorative quality for its buyers.

Survival of the original plate and interest in the
sitter led Joseph Sabin to produce restrikes in 1860.
The important of Pelham's print as a pioneer work,
and its resulting high price also led to outright fakes.
This fake (76) was probably reproduced photo-
graphically in the twentieth century. As with a
photographic half-tone, the palest areas of the original
image do not register. The image was impressed with a
plate margin, probably by dampening the paper, then
rolling it through a press over a blank copper plate.
However, it is not the same size as the original plate
mark. There was no attempt to match the brittle,
unbleached, laid paper of the 1728 print. A more
careful faker would have avoided this creamy, pressed
variety which is clearly of recent vintage. *DS*

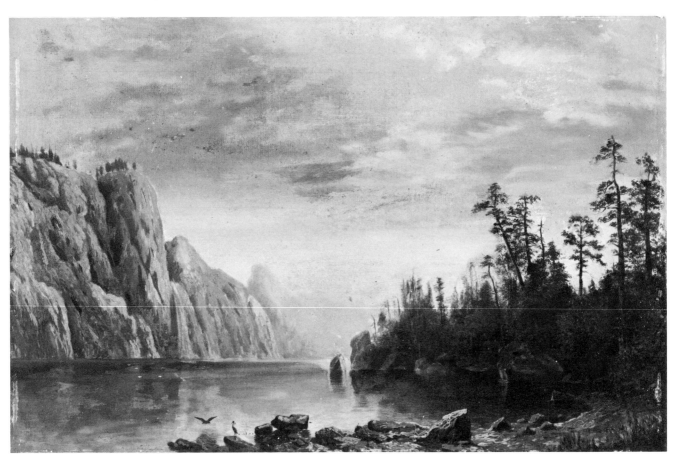

78
After Albert Bierstadt (1830-1892)
Western Lake Landscape
Oil paint over chromolithograph, ca. 1860, 20th century
H. 12" (30.5 cm); W. 18 1/2" (47 cm)
Herbert F. Johnson Museum of Art, Cornell University;
gift of Mr. and Mrs. Quinto Maganini
in memory of Albert Kingsbury

By the late 1860s, peak years of his career, the paintings of Albert Bierstadt were being made into chromolithographs. Mass-produced and printed in colored inks, these chromolithographs bore no traces of the artist's hand, yet they were varnished, and thus served as inexpensive substitutes for oil paintings.[1]

In this case however, which is representative of a great many examples of such deception, a chromolithograph has been painted over to produce a fake "oil painting." The lines and colors of the print were matched, and enough small details were changed to make the result seem original and convincing. The small size of the chromolithograph presented no problem, for Bierstadt painted finished Yosemite views in both large and small sizes. After the paint was applied, the back of the chromolithograph was glued to canvas, which in turn was glued to a panel. The painted surface was heavily varnished, and made to appear quite soiled. This fake was probably made in the 1930s or 40s, when Bierstadt's popularity was revived after a substantial decline since the 1880s.
DS

1. Catharine Beecher and Harriet Beecher Stowe, *The American Woman's Home* (New York, 1869), p. 91.

79
Asher B. Durand (1796-1886)
Lights and Shadows
Oil on canvas, ca. 1868
H. 15" (38.1 cm); W. 24" (60.9 cm)
Heckscher Museum, August Heckscher Collection

79a
Photograph of Wyant signature

79b
Photograph of signature under ultra-violet light

79c
Photograph of cleaned signature

As prices and reputations on the art market fluctuate, fakers may take an authentic painting and replace its signature with the name of an artist whose work will bring a greater sum. This is probably why this painting, by Asher B. Durand, had Durand's name altered to read "A. H. Wyant." Today the paintings of Durand, an important figure in the Hudson River School, are more highly esteemed than those of Wyant (1836-1892). However, during the 1920s Wyant's reputation as one of the major nineteenth-century American landscape painters was greater than that of Durand, and it is likely that the signature change took place at that time.

In this case, due to the similarity of the artists' names, the faker was able to retain part of the original signature, the capital "A" and the "an" in "Durand", to incorporate into the new Wyant signature. Photographs show the fake Wyant signature (79a), the signatures (79b) under ultra-violet light, with changes on all letters but the "A" and "an", and the newly cleaned signature (79c) with Durand's name, still somewhat obscured. By using solvents the conservator easily removed the added letters of Wyant's name to reveal the original Durand signature.[1] *JB*

1. Eva Ingersoll Gatling to Judith Bernstein, December 29, 1976.

95

Revivals

Revivals of previous artistic styles have occurred with surprising frequency throughout the history of art and design. An archaizing substyle developed in Greek art of the late Hellenistic period, artists in the court of Charlemagne looked to the classical past for inspiration, and even the Renaissance can be viewed as a revival of the art of classical Greece and Rome. In fact, the very word renaissance or re*birth* as it is translated, is related to the re*vival.* But to the modern mind, revival suggests most strongly the nineteenth century, a period in which revival styles abounded. These revivals did more than just borrow and recreate. They combined the spirit of the previous age, as well as specific motifs, with the dynamics of the age in which they were produced. Revival by definition is the act of reviving after a decline or discontinuation, of restoring to general use, of renewing, revivifying. As such, a revival implies a rebirth and subsequent growth. It is no mere copying or reproducing of an age past, rather it is a dynamic reinterpretation of that age in terms of the present.

What, though, is the psychology behind a revival style, and why do revival styles find periods of popularity? The most obvious reason is an admiration for the past and, perhaps, a longing to escape the present by recreating the past. The past, that is, as seen through the eyes of the present. Therefore a revival style often expresses, by its references, the desired ideals of the society which sponsors it. The parallels between the democracy of Greece and the moral mission of the new nation made the Greek Revival style seem especially appropriate in the early nineteenth century. Later, in the 1840s, the Gothic revival would replace the Greek and in so doing, provide America with an instant sense of past, of transplanted roots, and of culture. In the final quarter of the nineteenth century, the colonial revival embodied the strivings and emotions of a growing young country, proud of its accomplishments. In the words of Wallace Nutting, "We love the earliest American forms because they embody the strength and beauty in the character of the leaders of American settlement We carry on their spirit by imitating their work."[1] Again, the associations with the past were as important to the revival style as aesthetic considerations.

The colonial revival style is an especially interesting phenomena since it was the first revival of a native American past. By the time of the centennial in 1876, the new nation was mature enough to express a self-conscious curiosity in its own history. Indeed, even before the centennial celebration, there were those who showed an interest in early American antiques, an interest which led to avid, though limited, collecting.[2] The interest in collecting colonial antiques led to a parallel interest in producing revival versions of them and by 1872 this led to the observation, "the rage for old furniture not only occasions a demand, at most extravagant prices, for genuine articles of undoubted antiquity, but has led to a revival of some old styles, and to very successful imitations."[3] Soon after the centennial, interest in colonial antiques was strong enough to warrant the publication of books on the subject[4] and to provoke Clarence Cook, in *The House Beautiful* (1878), to encourage home decoration with colonial furnishings. Though no colonial *revival* furniture had been exhibited at the Philadelphia Centennial Exposition,[5] the patriotic atmosphere of the event had spurred the growing interest in the colonial. In the following decades, the colonial revival became an important force in American arts as Americans expressed "the desire to have in America an *American* style distinct from European models."[6] No longer was the artificial Gothic past of a few decades before necessary or appropriate.

In many ways the colonial revival was a compromise between the nineteenth-century revival styles and the reform movement in design of the late nineteenth and early twentieth century, for, though the new colonial was indeed a revival style, it was also a style which shared the interest of the reform movement in sturdy handcrafted objects. Certainly, the handmade furniture produced by Wallace Nutting bears a close relationship to the craftsman furniture of Gustav Stickley. Indeed, it has been said that Nutting added meaning to the sturdy, oak construction of craft furniture by combining these forms with a socially significant reference to the colonial past in his copies.[7] The revival of interest in hand craftsmanship was expressed in silversmithing as well by men such as Arthur Stone (89) and Franklin Porter, who owned a copy of Bigelow's *Historic Silver of the Colonies and Its Makers.*[8]

The colonial revival was not limited to the decorative arts by any means. In painting, interest in the colonial past was reflected by a new interest in colonial subject matter. This was not so much an accurate revival of eighteenth-century painting style as it was an expression of interest in a bygone day and in important pre-revolutionary monuments such as the Hancock house (95). To be sure, colonial buildings with their historic associations became important symbols in the late nineteenth century and consequently the colonial revival became a popular style due, in part, to its nationalistic associations. It was a style thought by many to be especially, indeed uniquely appropriate, to public buildings.[9] No longer did Americans need to look to ancient Greece for associations with democracy. In domestic architecture, adaptations of Mount Vernon and the Hancock house proliferated. By 1911, Montgomery Schuyler was moved to comment, "It is difficult to walk in the East end of Pittsburgh without coming on a Hancock house."[10] The colonial revival thus settled deeply into the fabric of American arts as an especially appropriate expression of national taste. It is still all round us today.

Certainly, during the nineteenth century the past was admired whether it be the distant past of ancient Greece or the more recent past of colonial America. But it was not treated with undue reverence. New forms were created, forms which had only a superficial relationship of stylistic motifs to creations of the period being revived. Motifs from various previous periods were mixed in an eclectic combination of styles which was totally original, and beneath all of these eclectic revival motifs was a common, underlying style factor which bespoke the nineteenth century. The revival object, therefore, reflects the needs, tastes and preferences of its own day. Often the revival object freely adapts earlier design to a new function (86) and makes free use of improved technology in construction. And it often consciously and unashamedly distorts and "improves" form and decoration to suit contemporary taste (82) or incorporates contemporary design movements or philosophies in its replication of old forms (85, 91). Thus revival objects can be seen as part of a developing series of replicas, a series of solutions to a design problem.

Yet there is another type of revival, a revival in which the historicism is more self-conscious and less innovative. It is a revival in which the intention, the force behind creation, is a desire to reproduce objects of the past or at least to recapture their appearance literally. This other facet of revivalism draws us very close to reproduction and these objects are in fact often called reproductions by their manufacturers. An example of this more literal pole of revivalism is provided by the Victorian revival of the 1930s and 1940s. Objects produced during this revival follow quite closely the prototypes of the Victorian era; there was no real dynamic force behind reinterpretations and few new forms were produced. Like many of the original productions, the revived pieces are made primarily by machine; they are simplified only slightly for convenience and economy. The major alteration in the revival pieces was a change of scale. The new Victorian was smaller, scaled down to fit the contemporary home, and usually no less expensive than the plentiful original prototypes. However, for the same money one could acquire a revival piece which was smaller in scale and was sturdy and strong. Thus the "newness" of the piece and the very factors which make it different from the original were considered advantages to be advertised rather than disadvantages to be hidden.[11] Even the accurate or literal type of revival therefore reflects the preferences of its time.

Whether scarcely altered or highly original, revival styles have long played a role in American arts and they have long been mocked and derided as derivative and sterile. We are only now beginning to appreciate them for their originality and for the insights they provide into their own time.

Kevin Stayton

Notes

1. Wallace Nutting, *Period Furniture* (1922), p. 2. Quoted by John Freeman, "The Arts and Crafts Ideology of Wallace Nutting's Colonial Revival," *Wallace Nutting: Checklist of Early American Reproductions* (Watkins Glen, New York, 1969), n.p.
2. See Rodris Roth, "The Colonial Revival and 'Centennial Furniture,'" *Art Quarterly* 27, no. 1 (Winter 1964): 57-81 and Richard Saunders, "Collecting American Decorative Arts in New England," *Antiques* 109, no. 5 (May 1976): 996-1003 and 110, no. 4 (October 1976): 754-763.
3. *The Great Industries of the United States* (Hartford and Chicago, 1872), p. 1103.
4. Arthur Little, *Early New England Interiors* (1878); Frank E. Wallis, *Old Colonial Architecture and Furniture* (1887); Irving W. Lyon, *The Colonial Furniture of New England* (1892); Alvin Crocker Nye, *A Collection of Scale Drawings, Details and Sketches of What is Commonly Known as Colonial Furniture* (1895); Newton Elwell, *Colonial Furniture and Interiors* (1896), to name a few.
5. Roth, p. 57.
6. William P. Rhoads, "The Colonial Revival and American Nationalism," *Journal of the Society of Architectural Historians* 35, no. 4 (December 1976): 242.
7. Freeman.
8. See Anne Farnam, "The Arts and Crafts Tradition in Essex County," *Essex Institute Historical Collections* 113, no. 1 (January 1977): 10, and Helen Porter Philbrick, "Franklin Porter, Silversmith," *Essex Institute Historical Collections* 105, no. 3 (July 1969): 156.
9. Rhoads, pp. 244-245.
10. Rhoads, p. 241, and Montgomery Schuyler, "The Building of Pittsburgh," *Architectural Record* 30 (September 1911): 278.
11. Elizabeth Shaffer, "Furniture for Today and Tomorrow," *Better Homes and Gardens* 19, no. 12 (August 1941): 46.

80
Side chair
American, ca. 1900-1930?
Mahogany
H. 50" (127 cm); W. 22 11/16" (57.7 cm);
D. 18 1/16" (48 cm)
Mr. Robert F. Trent

81
Side chair *1963.12*
Rhode Island, ca. 1795
Mahogany; birch, hard maple
H. 37 15/16" (96.4 cm); W. 20 7/16" (51.9 cm);
D. 18 3/16" (46.2 cm)
Yale University Art Gallery;
Mabel Brady Garvan Collection

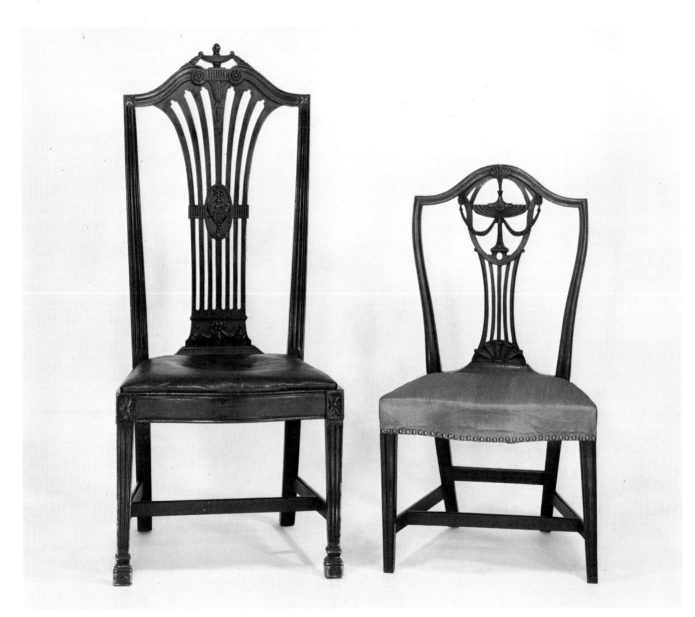

The colonial revival was actually an expression of interest in both colonial and early federal design sources; it was often as inaccurate in specific interpretation as it was in its definition of colonial. This unusual chair (80) borrows neoclassical motifs found in originals (81) and recombines them in an entirely uninhibited manner, freely augmenting the decoration with additions from the designer's imagination. Motifs shared by the two chairs include rosettes, urns, feather plumes, and swags, but in the revival chair these motifs have been shuffled — the flattened urn has moved to the crest rail, a second and completely different urn has been added to the splat and rosettes have been placed at major joints. The fluted legs of the revival chair are placed on plinths and joined to the seat rail with a rectangular patera. This type of leg is derived from European neoclassical examples such as the chairs designed by Robert Adam for the gallery at Osterly Park.[1] The shape of the chair bears only a token fidelity to neoclassical prototypes and, in the verticality of the back, reflects the lingering influence of the Art Nouveau style and of Charles Rennie MacIntosh. Unrelated and misunderstood decorative motifs have been piled onto an altered form; the result is a chair not unified in conception and somewhat restless in its decoration. But it is a chair which satisfied a demand for inexpensive, factory-produced furniture in the "colonial taste." *KS*

1. Illustrated, Maurice Tomlin, *Catalogue of Adam Period Furniture* (London, 1972), p. 32.

A revival of interest in the past can provide impetus for totally new and unique creations as well as for slavish recreations or misunderstood pastiches of past styles. This side chair was manufactured by A. H. Davenport and Company of Boston in 1896 after a design by Shepley, Rutan and Coolidge or possibly by Francis Bacon.[1] It was part of the original furnishings of the Converse Memorial Library in Malden, Massachusetts, a building designed by H. H. Richardson in 1885. Interest in the colonial revival was undoubtedly responsible for the windsor chair influence seen in this piece, and other elements of the chair are also related to earlier American chairs. The splat, for instance, is a free interpretation of Queen Anne splats and the gently sloping lines of the stiles moving forward into the seat are reminiscent of the "gondola" chairs of the early nineteenth-century Empire style. But its solid, massive Richardsonian form, is in the current of the reform movement in furniture and anticipated the American Arts and Crafts furniture of Gustav Stickley. A further element of avant garde originality is added by the fluid leaf carvings at the top of the splat, carvings which have been described as proto art nouveau.[2] *KS*

1. Anne Farnam, "A. H. Davenport and Company, Boston Furniture Makers," *Antiques* 109, no. 5 (May 1976): 1055.
2. Richard Randall, *The Furniture of H. H. Richardson* (Boston, 1962), n.p.

82
Side chair
A. H. Davenport and Company
Boston, Massachusetts, 1896
Oak
H. 37 1/2" (49.5 cm); W. 17 1/2" (44.4 cm);
D. 17" (43.2 cm)
Converse Memorial Library, Malden, Massachusetts

Due in part to the influence of the Arts and Crafts movement, the solid oak forms of the seventeenth century were among those most often copied in the first quarter of the twentieth century. Wallace Nutting was a collector and scholar of American antiques who began making and marketing honest reproductions in 1917. Unlike many of Nutting's products, which often combine the best and rarest of individual characteristics into a single piece differing in scale and proportion from any original,[1] this copy (83) is quite close to its model, a Wethersfield tulip and sunflower cupboard attributed to Peter Blin and probably made around 1690 (84). It comes very close to crossing the vague line between revival and reproduction; only in the applied turnings, which seem to flatten into the surface of the cupboard in comparison with the strongly three-dimensional originals and in the increased open space surrounding the carving do we discern major alterations. Nutting advertised this cupboard with the comment that it "... is a very careful copy of the best original ... every measurement is worked out to the thirty-second of an inch."[2] This cupboard, made under Nutting's direction and branded with his name, is perhaps the product of a collaboration of his workmen, including the cabinetmaker Ernest Gestrom, the turner H. H. Adams, the carver Frank Newcomb, and the finisher Augustus Bartalucci.[3] This model was offered for sale in the 1928 edition of Nutting's catalogue at a price of $495.[4] *KS*

1. Kane, *Seating Furniture*, pp. 265-266.
2. *Antiques* 10, no. 3 (September 1926): 244.
3. These workmen are named in a letter from Leola Grant to Mr. Archibald W. Dunn dated 8 May 1975.
4. *Wallace Nutting Catalogue*, 7th ed., (Framingham, Massachusetts, 1928), p. 67 and price list, p. 5.

Peter Blin of Wethersfield made tulip and sunflower chests as well as cupboards, and it is this group of chests which inspired the twentieth-century example seen here, a piece produced by Danersk Furniture (Erskine-Danforth Corporation of New York, Chicago and Los Angeles) at their Stamford factory. Danersk produced high quality, hand-crafted items. An advertisement in *Antiques* of November, 1931, claims, "The Scotch and English craftsmen in the Danersk Colony build furniture the honest and enduring way, scorning all of the cheap shortcuts used in mass-made furniture."[1] Yet this Danersk chest cannot be considered an accurate reproduction by any means, for changes from the seventeenth-century

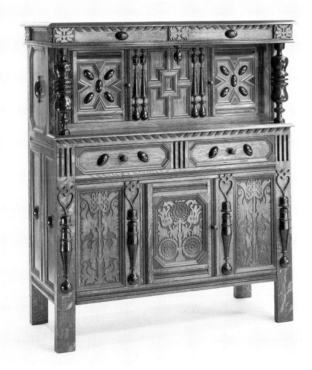

83
Cupboard
Wallace Nutting Company (1917-1936)
Framingham, Massachusetts, ca. 1928
Oak; white pine
H. 57 1/2" (146 cm); W. 48 1/2" (123.2 cm);
D. 20 1/2" (52.1 cm)
Mr. and Mrs. Archibald W. Dunn

84
Cupboard *1887.7*
Attributed to Peter Blin (active ca. 1670-1710)
Wethersfield, Connecticut, ca. 1670-1710
Oak; cedar, maple, pine, poplar
H. 56 1/4" (142.9 cm); W. 49 1/4" (125 cm);
D. 21 1/2" (54.6 cm)
Yale University Art Gallery;
bequest of Charles Wyllys Betts, B.A. 1867

type have occurred in materials, design and function. In this chest, walnut has replaced oak as the primary wood and turned, applied spindles on the stiles of the original have been replaced by carved guilloche bands. Whereas the top of the original chest lifted to reveal a deep storage space, the top of this chest is stationary. Instead, the front of the chest falls forward to create a flat surface and reveal three drawers on the interior. The old chest form has been adapted to modern usage. This chest has a rococo label inside the top interior drawer and is branded with the Danersk name and windsor chair mark on the back. *KS*

1. *Antiques* 20, no. 5 (November 1931): 301.

The Victorian revival which had begun to appear in the 1930s was given impetus by World War II. In a time of crisis, familiar old-fashioned forms had a great appeal. Furthermore, since production was geared to war materials, new furniture lines were scarce; as a result, New York stores began showing authentic Victorian pieces in new settings,[1] further stimulating interest in the Victorian revival. Among the Victorian forms "reproduced" was the balloon-back chair. Superficially, this revival balloon-back chair (86) bears a fairly close relationship to a mid-nineteenth-century balloon-back side chair (87) made in a shop in which hand craftsmanship was still practiced. Though it is true that the machine carving

on the revival piece is coarser and more facile than that on the older chair, hasty machine carving was a feature that developed in the nineteenth century and which appears on many Victorian chairs. The real difference in the two chairs lies in details of construction and in the slight distortion of scale and proportion seen in the revival piece. The revival is made of walnut, pieced together of small units, and the grey-green tone of the wood indicates an artificial finish. In addition, screws and modern furniture construction techniques are apparent in the undercarriage of the seat, and the modern upholstery appears to be the original. According to its label, this chair was sold by the Rike-Kumler Company, Dayton, Ohio; it was probably manufactured by the Nahon Company of New York.[2] *KS*

1. *Interiors* 103, no. 4 (November 1943): 34.
2. Compare with a chair advertised in *Interiors* 101, no. 12 (July 1942): 55.

86
Side chair
Probably New York, ca. 1940-1945
Walnut; oak
H. 34" (86.4 cm); W. 18 1/2" (47 cm);
D. 16 1/2" (41.9 cm)
Mr. and Mrs. Jack K. Stayton

85
Chest with drawers
Danersk Furniture (Erskine-Danforth Corporation)
Stamford, Connecticut, ca. 1930
Walnut; mahogany
H. 39 7/8" (101.3 cm); W. 49 1/8" (124.8 cm);
D. 17 11/16" (55.5 cm)
Yale University Graduate School

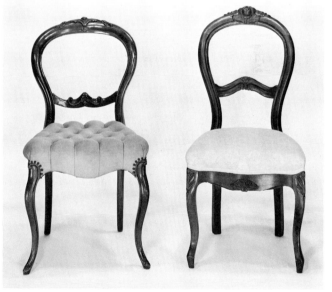

87
Side chair
American, ca. 1850
Walnut; ash
H. 35 1/2" (90.2 cm); W. 18 1/4" (46.4 cm);
D. 17" (43.2 cm)
Mr. and Mrs. Jack K. Stayton

88
Silver teakettle on stand *1976.10.2a,b,c*
Gorham Corporation
Providence, Rhode Island, 1911
H. 12" (30.5 cm); W. 10 1/4" (26.1 cm);
D. 6 1/4" (16 cm); WT. 53 oz, 5 dwt (1650.8 gm)
Yale University Art Gallery;
gift of Lydia Evans Tunnard
in memory of Rosamond Allen Evans

By 1760 the silver teakettle on stand was beginning to go out of style in favor of the tea urn.[1] Teakettles on stands had been quite popular in the rococo style of the mid-eighteenth century, however, and the *form* was revived in the nineteenth century. In fact, the teakettle on stand was an important part of tea services produced and sold as matched sets in the nineteenth and twentieth centuries.[2] Thus, when the colonial revival style became an important part of the American silver industry in the early twentieth century and an interest developed in producing fluted neoclassical silver, a new design had to be created for the teakettle on stand. An example of the result is this piece (88) in which a kettle form in the neoclassical taste was added to a stand to create an object with no exact parallels in silver of the late eighteenth century. This revival piece expresses the requirements of its own time in both its form and its detail. The languid lines of the support between the kettle and the stand are especially reminiscent of Art Nouveau design. This teakettle bears the Gorham Company "pipe" mark for the year 1911. *KS*

1. Bernard and Therle Hughes, *Three Centuries of English Domestic Silver* (New York, 1952), p. 174.
2. See Larry Freeman, *Victorian Silver* (Watkins Glen, New York, 1967), pp. 97-99, 106-114.

With the revival of interest in the colonial period, a renewed interest in the craft process as well as in the colonial style developed. This interest was given further stimulation by the Arts and Crafts movement. In silversmithing, old craft traditions were carried on by such men as Arthur J. Stone, whose establishment, Stone Associates of Gardner, Massachusetts, produced the creampot shown here (89). Stone was born and trained in England. He emigrated to New Hampshire in 1884 and in 1901 he opened his own shop for the production of hand wrought silver ware.[1] His pitcher is related in form to a cream pitcher of inverted pear shape made by Paul Revere (90), probably in the early 1780s.[2] Like the Revere pitcher, Stone's pitcher exhibits signs of handcraftsmanship. The base has been made separately and soldered on and the interior surface of the pot displays the rippled surface caused by the process of raising the silver by hand. Stone, however, has given a greater stability to a basically unstable rococo form; and he has replaced gadrooned ornament on the lip and the edge of the foot with a solid molding. In addition, he has replaced the cut, scrolled handle of the Revere pitcher with a heavier cast handle. The result is a simplified pitcher which reflects the neoclassical aesthetic as much as the rococo. The base of the creampot bears the "hammer" mark of Stone Associates, the date 1928, and the letter G, probably the initial of the shop assistant who made the piece. *KS*

1. Dorothy Rainwater, *American Silver Manufacturers* (Hanover, Pennsylvania, 1966), pp. 175-176.
2. Buhler and Hood, *American Silver*, no. 243.

89
Silver creampot
Stone Associates (ca. 1901-1955)
Gardner, Massachusetts, 1928
H. 4 3/8" (11.1 cm); Diam. base 2 7/16" (6.2 cm);
Diam. top 2 7/8" (7.3 cm); WT. 8 oz, 7 dwt (259 gm)
Yale University Art Gallery;
bequest of Peter J. Meyer

1975.48a

90
Silver creampot (not illustrated)
Paul Revere (1735-1818)
Boston, ca. 1780
H. 4 15/16" (12.5 cm); Diam. base 2 15/16" (5.9 cm);
WT. 5 oz, 6 dwt (164 gm)
Yale University Art Gallery;
gift of Susan Morse Hilles

1959.17.3

Modern adaptations of early American forms are proof that the colonial revival has never entirely disappeared. This teapot (91) made by Lunt Silversmiths is based on a fluted oval teapot made by Paul Revere around 1795, a teapot similar to the one illustrated here (92). However, the form has been freely adapted and changed. The vertically elongated proportions of the revival piece are completely different from the horizontally-oriented proportions of the original. Furthermore, the bright-cut decoration of the Revere teapot has been adapted to machine production for use on the Lunt example. In fact, the Lunt teapot reveals a method of manufacture and a use of material entirely different from its prototype. Rather than being handmade of sterling silver, as the Revere teapot is, the Lunt example is machine crafted of base metal, then silverplated. The Lunt teapot is part of a set which includes a tall coffeepot, a sugar bowl and a cream pitcher, each of which echoes the basic fluted oval shape of the teapot; a similar teaset was advertised in 1931 by Gebelein Silversmiths.[1] In Revere's own sets, however, the shapes of the pieces which accompany the teapot are varied; for instance, the sugar basket is urn shaped, the cream pitcher helmet shaped.[2] The decision of Lunt Silversmiths to adapt the teapot form to each piece in the set rather than to follow Revere's individual models reflects the twentieth-century desire for closely matched sets. *KS*

1. *The Antiquarian* 16, no. 1 (January 1931): 19.
2. See Katherine H. Buhler, "Towards a Tea Set by Paul Revere," *Minneapolis Institute Bulletin* 50, no. 2 (June 1961): 5-24.

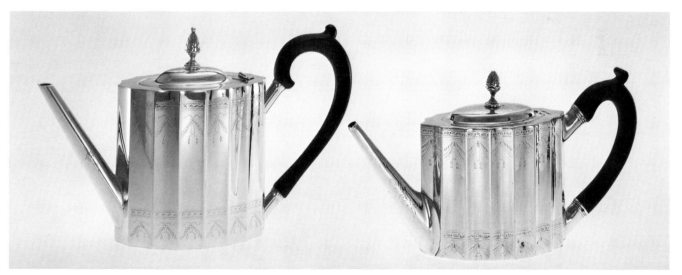

91
Silver-plated teapot
Lunt Silversmiths Incorporated
Greenfield, Massachusetts, ca. 1976
H. 7 1/16" (17.9 cm); W. 3 7/8" (9.8 cm);
L. 11 3/16" (28.4 cm); WT. 25 oz, 4 dwt (781 gm)
Museum Shop, Museum of Fine Arts, Boston

92
Silver teapot
Paul Revere (1735-1818)
Boston, ca. 1790-1795
H. 6" (15.2 cm); W. 3 1/2" (8.9 cm);
L. 11 3/8" (28.9 cm); WT. 19 oz, 12 dwt (608 gm)
Yale University Art Gallery;
Mabel Brady Garvan Collection

1930.959

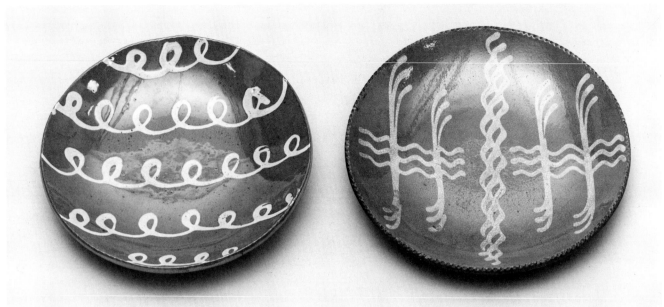

93
Redware plate *1977.37*
Lester Breminger
Robesonia, Pennsylvania, 17 January 1976
H. 1 5/8" (4.2 cm); Diam. 10 3/8" (26.4 cm)
Study Collection, Yale University Art Gallery

94
Redware plate *1931.1824*
Possibly Connecticut (Norwalk), ca. 1815
H. 1 1/2" (3.9 cm); Diam. 10 5/8" (27 cm)
Yale University Art Gallery;
Mabel Brady Garvan Collection

The practice of making utilitarian plates such as these was introduced into this country from Europe before 1800. Unlike traditional wheel-thrown pottery, these plates were molded over wooden or clay forms called bats. During the nineteenth century they were made in Pennsylvania, New Jersey, New York and in southeastern Connecticut. Usually slight variations in outline, coggling of rims, decorations, and weight will indicate regional preferences.[1] One of these plates (94) for instance, is associated with Connecticut because its decoration is related to examples made by the Asa Smith pottery in Norwalk,[2] and because it has the typical shallow curving side found on Connecticut examples. On the other hand, the plate (93) made by Mr. Breminger, although ostensibly a reproduction of a Pennsylvania piece, shows a certain freedom from tradition which is characteristic of revivals. It lacks the deeply coggled rim usually found on Pennsylvania examples and its slip decoration is not pressed into the clay body, making it possible for the decoration to chip off in use. Such a problem would normally be avoided in utilitarian wares. Mr. Breminger's plate is signed on the back "L Breminger/ Robesonia, Pa/ Jan 17, 1976/ very cold."[3] *FJP*

1. See Joseph Johnson Smith, *Regional Aspects of American Folk Pottery* (York, Pennsylvania, 1974), p. 17.
2. Smith, *Regional Aspects*, fig. 34.
3. Mr. Breminger is one of several potters working in rural Pennsylvania making pottery of this type. His pieces are marketed in local museums and historical societies.

95a
Edward Lamson Henry (1841-1919)
The Hancock House
Photograph, ca. 1863
New York State Museum;
Henry Collection

95
Edward Lamson Henry (1841-1919)
Hancock House (see p. 62)
Oil on wood panel, 1865
H. 7" (17.8 cm); W. 8 1/2" (21.6 cm)
Yale University Art Gallery;
Mabel Brady Garvan Collection

1948.99

Reflecting the nostalgia for earlier days which became increasingly prevalent in post-Civil War American painting, Henry's work is a revival in this sense: he tried to rekindle awareness of the nation's heritage in myriad paintings of historic houses, steam engines, carriages and costumes.

Henry carefully gathered artifacts, sketches, old prints and written descriptions before attempting a painting. Early interested in historic preservation, he worked actively to save buildings from destruction. He also used the relatively modern technique of photography to preserve the past. *Hancock House* was based on a photograph Henry shot in Boston before the structure was, in his words, "taken down for common modern houses" in 1863.[1]

In this painting liberties with scale tend to monumentalize the gambrel-roofed house. Writ large, the house dwarfs colonial-costumed figures promenading upon the front walk. The figures, along with a costumed man tending a carriage, may be based upon Henry's own vast collection of old clothes and carriages. Although the building is overscaled, every detail from the photograph has been meticulously rendered in what really must be considered a portrait of the Hancock house.

Henry's paintings were widely reproduced in prints, stimulating interest in America's past. His style, unchanging for half a century, is related in spirit to nineteenth-century folk artists who often painted portraits of place. In that sense, Henry's *oeuvre* comprises less a revival than a survival in American painting. *DPC*

1. Elizabeth McCausland, *The Life and Work of Edward Lamson Henry, N.A., 1841-1919* (Albany, New York, 1945), p. 129.

96
Thomas Eakins (1844-1916) *1961.18.19*
Retrospection
Oil on wood, 1880
H. 14 1/2" (36.8 cm); W. 10 1/8" (25.7 cm)
Yale University Art Gallery;
bequest of Stephen Carlton Clark, B.A. 1903

Retrospection is one of numerous works which Eakins executed after the Centennial Exposition had reawakened interest in earlier American furniture styles.[1] It illustrates the particularly complex way in which the term revival applies to painting. Eakins strongly evoked the mood of early nineteenth-century genre painters through the use of antique props such as chairs, spinning wheels, tilt-top tables, and old dresses.[2] At the same time, he used a somber Spanish palette and Rembrandtesque lighting gained during his European training. Thus, this small painting "revives" a number of periods, yet it retains its integrity and imitates none. Eakins displays as much interest in texture and surface as in subject matter, and the piece has the fragile, almost transitory quality of the oil sketches which began to concern painters at this time.

The empire gown and the Chippendale chair reappear in several other works. Indeed, his use of antiques over three decades underscores a continuing interest in the evocative powers of old furniture. Eakins' use of the chair is especially poetic. The anthropomorphic shape with its ears, back, and legs, seems almost a metaphor for the pensive sitter. Eakins' sense of nostalgia is fundamentally different from that of E. L. Henry (95). Avoiding Henry's careful documentation of past customs and places, Eakins employed antiques to stimulate feelings of melancholy and the passage of time in a romantic associative manner. Memories are, in effect, left to the viewer. *DPC*

1. These works, numbering more than a dozen, are catalogued in Gordon Hendricks' "Checklist of Works by Eakins" in his *The Life and Works of Thomas Eakins* (New York, 1974), pp. 315-352.
2. Donelson F. Hoopes, *Eakins Watercolors* (New York, 1971), p. 40.

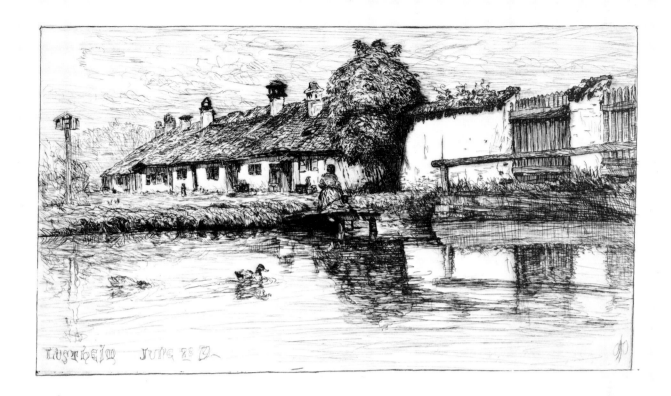

97
Otto H. Bacher (1856-1909) *1965.33.507*
Lustheim
Etching, 1879
H. 6 7/8" (17.5 cm); W. 10 3/4" (27.3 cm)
Yale University Art Gallery;
gift of Allen Evarts Foster, B.A. 1906

Otto Bacher's *Lustheim* is representative of the Etching Revival which began in France early in the 1800s, spreading to England and the United States. At a time when interest in seventeenth-century Dutch art was high, etchers consciously looked to the evocative plates of Dutch printmakers when they reasserted the validity of etching as an artistic medium.

Lustheim recalls the plates of Rembrandt in both its choice of humble subject and in handling. The Rembrandtesque film of ink left on the plate to render dramatic light and dark contrasts while imparting richness of surface was a popular Revival technique.

Predictably, *Lustheim* carries marks of its own time as well as the past. Critics thought Bacher's work typified the emphasis on frank depiction of "ugly" lowlife that stemmed from Courbet's mid-century realism.[1] Bacher's vigorous use of line owes as much to Frank Duveneck, the American with whom Bacher studied, as it does to Rembrandt. The Revivalists were open to new techniques. *Lustheim* was probably etched out of doors in the Bavarian countryside, using the "positive process" of P. G. Hamerton, an English etcher. The plate was incised while it lay in an acid bath, permitting the artist to see his drawing immediately as the acid attacked the plate.[2]

Finding both stylistic inspiration and justification in the work of the seventeenth-century Dutch, members of the Etching Revival concerned themselves with contemporary artistic issues, for the Revival was also a conscious effort to supplant engraved copies of paintings with original etchings. *DPC*

1. S. R. Koehler, "The Works of the American Etchers. XVI. Otto H. Bacher," *The American Art Review* 2, no. 1 (1881): 51-52.
2. Otto H. Bacher, *With Whistler in Venice* (New York, 1908), p. 99.

103

Reproductions

As we are using the term, *reproductions* are duplicated of existing works of art which are made and sold as copies, not as the "genuine article." In some forms of art, however, such as the making of prints (119-123), the manufacture of pewter in brass molds (105, 106), and multiple castings of sculpture, the idea of reproduction is implicit in the process of their creation. If made or authorized by the original artist, each impression or casting is, in effect, an original. In painting, the practice of having young artists copy the work of older ones (7) is a centuries-old teaching and learning device. It has also been common practice for artists to duplicate their own work (5), although modern variations in this form of duplication (117) raise the question of the rights of the artist and the nature of an original work of art. The most frequently discussed dimension of reproductions is their potential danger to the collector. As Ruth Webb Lee has noted, however, "a reproduction becomes a fake only when it is sold as a genuine antique."[1] This frequently happens with glass (70) and other types of decorative arts objects, especially after the passage of fifty or more years has taken away their "new" look, but this type of deception is not our concern here.

One of the most interesting minor themes of American culture is the widespread and continuing popularity of modern reproductions of the arts of colonial America and the early Republic. Meticulous copies of seventeenth-and eighteenth-century designs have been made at least since the 1920s, and probably

earlier, although many early "reproductions" were by no means faithful to the original, and are better classified as revivals (85). By the 1930s, reproductions were made by many firms,[2] and their existence provoked comment in the collector's journals and elsewhere.[3] The whole character of the movement was given added status and legitimacy by the introduction of the Williamsburg Reproductions Program in 1937. This extensive program of reproduction furniture, silver, brass, pewter, prints, wallpaper, paint, sconces, glass, china, mirrors, textiles and other "decorative pieces" now numbers over 1700 objects, made by such manufacturers as Kittinger, Stieff, and many others.[4]

As the Williamsburg program indicates, reproductions of nearly everything are available today. They are made by large companies (103, 109) or by individuals working alone, or at most with an apprentice or two. Some of these individuals, such as Robert Whitley, feel themselves very much a part of the master craftsman tradition of the eighteenth century.[5] Several trends emerge out of this diverse multitude. Many reproductions are of objects associated with patriotic events, such as the signing of the Declaration of Independence (102), or with patriotic figures, such as Paul Revere (103). These objects express feelings of nationalism and a desire to exalt "the patriotism, high purpose, and unselfish devotion of our forefathers to the common good," sentiments which others have found as motivating factors in the early stages of the colonial revival in architecture.[6] On the other hand, many reproductions are of plain, utilitarian things which are thought to represent "the simplicity and honesty of designs rooted in our great past."[7]

The emphasis on the beauty and harmony of "timeless traditional designs" which surrounds the promotion of these reproductions links them with the romanticism of earlier nineteenth-century revivals. It is argued by one company that the use of reproductions in the modern home adds not only "undeniable grace and beauty but also the implication of stability, authority, and roots-to-living in this topsy-turvy age."[8] This is a form of "pseudo-scientific" romanticism, however, which differs from earlier expressions in its insistence on meticulous attention to detail, exact copying, and such related paraphernalia as hallmarks and certificates of authenticity. The quality of a reproduction is thus generally judged on the basis of its exactness. In 1926, *Antiques* noted that "the objection to reproduction furniture lies not in its occasional excellence, but in its too frequent inferiority. Far too many of the specimens that are presented as faithful copies of the old are not copies at all; they are merely rude approximations, and, as such . . . doubly spurious."[9] These same standards are still accepted today; quality is achieved through the exact copying of the original.

Whether exact or not so exact, there is no question but that reproductions of all sorts of art objects are popular today. Many museums, such as The Metropolitan Museum of Art, derive considerable revenue from their sale (111).

Many museums routinely use new copies of furniture brasses and upholstery fabrics as part of their restoration process. Often, as in the case of textiles, this is done in order to save the extremely fragile and light-sensitive originals which, in any event, have not survived in great numbers. The use of modern textiles, wallpaper, paint colors, and hardware is extensive in many historic houses and museums, especially those with period rooms. George Francis Dow and other early house restorers freely substituted new objects when original ones were unavailable, and also made extensive use of reproduction windows, sheathing, paneling, locks, doors, and other architectural trim.[10] Some "historic houses," such as the modern re-creations at Plimoth Plantation, are furnished exclusively with reproduction objects.

It is interesting to speculate on the degree to which the use of these twentieth-century products affects our interpretation of history. Much of "the sense of the past" gained by visits to period rooms and historic houses is derived from a response to objects which were actually made in our own time, and which probably reflect our modern sensibility more accurately than that of the past.

Gerald W. R. Ward

Notes

1. Ruth Webb Lee, *Antique Fakes and Reproductions* (Wellesley Hills, Massachusetts, 1950), p. 6.
2. Nancy McClelland, *Furnishing the Colonial and Federal House* (Philadelphia, 1936), pp. 7-10.
3. "The Editor's Attic," *Antiques* 9, no. 4 (April 1926): 219-220, and Charles Messer Stow, "As to Reproductions," *The Antiquarian* 12, no. 3 (April 1929): 104.
4. See Craft House, *Williamsburg Reproductions: Interior Designs for Today's Living* (Williamsburg, Virginia, 1971), pp. 20-21.
5. For example, see Whitley's advertisement in *Antiques* 107, no. 5 (May 1975): 990.
6. Craft House, *Williamsburg Reproductions*, p. 10. The initial appeal of colonial revival architecture is discussed in William B. Rhoads, "The Colonial Revival and American Nationalism," *Journal of the Society of Architectural Historians* 35, no. 4 (December 1976): 239-254.
7. *The Ethan Allen Treasury of American Traditional Interiors* (New York, n.d.), p. 4.
8. Craft House, *Williamsburg Reproductions*, p. 24.
9. "The Editor's Attic," pp. 219-220.
10. Barbara M. Ward and Gerald W. R. Ward, *The John Ward House* (Salem, Massachusetts, 1976), pp. 25-34.

Expansion of sets had always been a rather common occurrence in the decorative arts,[1] but with the growing interest in colonial furnishings in the nineteenth century, more and more sets of chairs were expanded. As early as 1844, the Connecticut Historical Society records the gift of "an ancient and handsome chair . . . and six new ones to match the former."[2] Similarly, a set of chairs made for E. H. Derby was expanded in the mid-nineteenth century. The copies (98) were faithful and accurate replicas of the original chairs (99), which were carved by Samuel McIntire and based on plate 2 in the third edition of George Hepplewhite's *The Cabinet-Maker's and Upholsterer's Guide* (London, 1794).[3]

Though the copy seems to be nearly identical in form and detail to the original, the Victorian concern with richness is betrayed in the handling of the carved decoration which is slightly heavier, deeper, and more meticulous than the delicate carving of the original. A careful comparison of the copy and the original reveals a somewhat mechanical execution in the acanthus of the urn of the copy and in the pendant grapes on the legs. *KS*

1. Martha Gandy Fales, *Early American Silver* (New York, 1970), p. 122.
2. Connecticut Historical Society, *Connecticut Chairs in the Collection of the Connecticut Historical Society* (Hartford, 1956), p. 14.
3. Richard H. Randall, Jr., *American Furniture in the Museum of Fine Arts, Boston* (Boston, 1965), pp. 203-207.

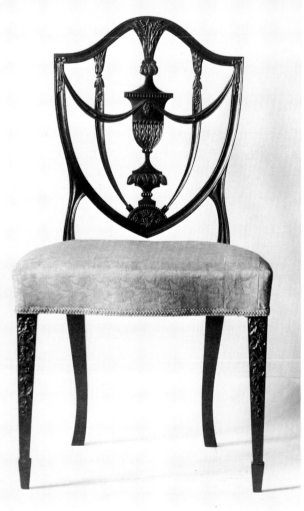

98
Side chair
Massachusetts, ca. 1850
Mahogany; ash
H. 38 1/2" (97.8 cm); W. 21" (53.3 cm);
D. 21" (53.3 cm)
Museum of Fine Arts, Boston;
gift of S. Richard Fuller
in memory of his wife, Lucy Derby Fuller

99
Side chair
Carving by Samuel McIntire (1757-1811)
Salem, Massachusetts, ca. 1790-1795
Mahogany; ash, birch
H. 38" (96.5 cm); W. 22 1/2" (57.1 cm);
D. 18 3/8" (46.7 cm)
Museum of Fine Arts, Boston;
gift of S. Richard Fuller
in memory of his wife, Lucy Derby Fuller

Although Breuer's Cesca chair was designed fifty years ago, it is still considered modern. Beginning in 1965 it was made by Gavina of Milan whose product (101) is here designated a "classic" to distinguish it from a Breuer original. The abiding popularity of this design has led manufacturers to produce copies using less costly materials and procedures.[1]

Throughout the classic elements are carefully detailed. The front faces of the metal tubing and the armrests are positioned at the same angle; the tubing of the arm is carefully recessed into the wooden armrest and together these elements slope forward in a gentle curve; the front edge of the seat is rounded to follow the arch of the front legs. The La Vita knock-off has less finesse in its small details. The front faces

of the wooden armrests and metal tubing describe an oblique angle; the wooden armrests do not fit snugly and their ends curve more steeply; the front edge of the seat is less rounded. The regularity of the machine-caning on the knock-off (versus the hand-caning on the classic) and the steel tubing plated with chrome are two examples of the less costly processes used in its manufacture. *BZW*

1. Linda Foa, "Knocking off the Classics," *New York* 9, no. 3 (January 19, 1976): 54.

100
Cesca armchair
Designed by Marcel Breuer (b. 1902) in 1928
Reproduced in Italy and imported by La Vita, New York
Chrome-plated tubular steel, beechwood-type wood, cane
H. 30 1/4" (76.8 cm); W. 24" (61 cm);
D. 20 3/4" (52.7 cm)
James Furniture Company

101 *1971.67.3*
Cesca armchair
Designed by Marcel Breuer (b. 1902) in 1928
Reproduced by Gavina S.p.A., Milan, Italy, from 1965
Polished tubular steel, black painted beechwood, cane
H. 30 3/4" (78.1 cm); W. 22 3/4" (57.8 cm);
D. 21 1/4" (54 cm)
Yale University Art Gallery;
Millicent Todd Bingham Fund

102
Silver inkstand
George C. Gebelein (1878-1945)
Boston, 1928-1929
H. 7 15/16" (20.2 cm); W. 11" (27.7 cm);
D. 8" (21.1 cm); WT. 40 oz, 4 dwt (1246 gm)
Yale University Art Gallery;
gift of Edwina Mead Gagge

1976.19a-d

George C. Gebelein was an important figure in the handcraft movement of the early twentieth century. He learned the craft of silversmithing as an apprentice in the Boston firm of Goodnow and Jenks and in 1909 he opened his own shop at 79 Chestnut Street. Gebelein collected and sold antique silver and specialized in making creative pieces in the colonial revival style. In addition he fashioned numerous reproductions of colonial silver using the techniques and tools of the eighteenth century.[1]

In 1928 and 1929 Francis P. Garvan commissioned Gebelein to make thirty reproductions of the famous inkstand by Philip Syng (1703-1789) which was used by the signers of the Declaration of Independence and the Constitution. Garvan was the founder and President of the Chemical Foundation which was established after World War I to foster American independence in the production of chemicals. This inkstand (102) was made for Larkin G. Mead, a fellow member of the Foundation, and is inscribed "Commemorating Our Fight for American Chemical Independence."[2] Because of its association with the founding fathers, Garvan chose to have the Syng inkstand reproduced in honor of individuals whom he felt had made significant contributions to the continued independence of the United States. *BMW*

1. Margaretha Gebelein Leighton, *George Christian Gebelein, Boston Silversmith 1878-1945* (Boston, 1976), pp. 12-24, 53-55, 69-91.
2. Leighton, *George Christian Gebelein,* p. 74. Additional information provided by Mr. J. Herbert Gebelein from the files of Gebelein Silversmiths Incorporated.

Though the reproduction porringer (103) duplicates the dimensions of the original and reproduces the Apthorp crest, it does differ from the one made by Paul Revere (104). Unlike the Revere porringer, which was hand-wrought, the reproduction was spun, giving it a brash, hard quality in comparison to the warm luster of the old porringer. The curves and angles in the handle of the reproduction are less clearly defined than those on the original. Furthermore, the c-curves and s-curves on the reproduction lack the precision of Revere's work.

The choice of the key-hole pierced handle reflects the continued popularity of a particular decorative form. Introduced in the colonies in the second quarter of the eighteenth century, it became universally popular by the middle of the century, and remains the favored pattern for reproductions.[1] The choice also represents continued interest in an historic American figure. Paul Revere's fame as a patriot was doubtless as important in the selection of the object as any tribute to his skill as a silversmith. The choice also reflects the persistent appeal of the porringer form, although the new porringer is promoted as an ashtray or candy dish, whereas porringers were traditionally used as eating and drinking utensils. *BZW*

1. Martha Gandy Fales, *Early American Silver for the Cautious Collector* (New York, 1970), p. 52.

103
Silver-plated porringer (see p. 74)
International Silver Company
Meriden, Connecticut, 1973-1974
H. 2" (5.1 cm); Diam. 5 1/2" (14 cm);
L. handle 3" (7.6 cm); WT. 10 oz, 2 dwt (313 gm)
Study Collection, Yale University Art Gallery

1977.39

104
Silver porringer (not illustrated)
Paul Revere (1735-1818)
Boston, ca. 1795-1800
H. 2" (5.1 cm); Diam. 5 1/2" (14 cm);
L. handle 3" (7.6 cm); WT. 9 oz, 17 dwt (305 gm)
Yale University Art Gallery;
Mabel Brady Garvan Collection

1930.1199

105
Pewter spoon (not illustrated)
Recent casting from the accompanying mold (106)
L. 7 11/16" (19.5 cm)
Study Collection, Yale University Art Gallery

106
Brass spoon mold (not illustrated)
American, 1700-1740
L. 8 1/16" (20.5 cm)
Yale University Art Gallery

Pewter spoons had short life spans because they were easily lost or broken. Their limited life and wide use created a large demand for spoons, and millions were produced during the eighteenth and nineteenth centuries. Because spoon molds were small and simple, neighbors or friends often joined together to purchase and share them. In this way they guaranteed themselves a steady supply of spoons. Few early American pewter spoons have survived, but many spoon molds from this period do exist. This old brass spoon mold (106), probably made in the early eighteenth century, produced wavy-handled, rat-tailed spoons. The accompanying spoon (105), a modern casting from this authentic mold, could be easily mistaken as an old spoon. Positive identification and dating of spoons is difficult because pewter spoons were rarely stamped with a maker's mark. Only the surface appearance identifies this spoon as newly cast, and with the help of acid or a blow torch, this finish could be made to look old.[1] A spoon cast from old pewter in an old mold is the most accurate reproduction available. A noted pewter scholar, H. J. L. J. Masse aptly warned, "Spoons are best left alone by the novice."[2] *ESC*

1. *The Pewter Collectors' Club of America Bulletin* 60 (August 1969): 12.
2. Percy E. Raymond, "Wrong-uns," *The Pewter Collectors' Club of America Bulletin* 21 (February 1948): 33.

107
Pewter plate
Cast ca. 1970 from a plaster of paris impression
Diam. 7 3/4" (19.7 cm)
Mr. and Mrs. Charles F. Montgomery

108
Pewter plate
Thomas Danforth II (w. 1755-1782) or
Thomas Danforth III (w. 1777-1820)
Middletown, Connecticut, 1755-1820
Diam. 7 3/4" (19.7 cm)
Mr. and Mrs. Charles F. Montgomery

Making a plaster of paris impression of an authentic pewter piece and using this as a mold results in a reproduction that inherits the wear marks and surface appearance of the original. Although casting from the plaster impression results in a loss of detail, many collectors and dealers have attributed this to normal wear and, as a result, mistaken such reproductions as authentic.[1] However, an understanding of the pewterer's traditional finishing process eases the problem of differentiating between this reproduction (107) and a real Danforth plate (108).[2] Whereas the authentic plate exhibits the results of the pewterer's careful finishing, the reproduction shows a loss of sharpness from the process of casting. The skimming marks are almost nonexistent, the incised lines are inconsistent and faint, and the touch's background has little sharpness or clarity. *ESC*

1. *The Pewter Collectors' Club of America Bulletin* 60 (August 1969): 10-12.
2. John Carl Thomas, *Connecticut Pewter and Pewterers* (Hartford, Connecticut, 1976), pp. 6-12.

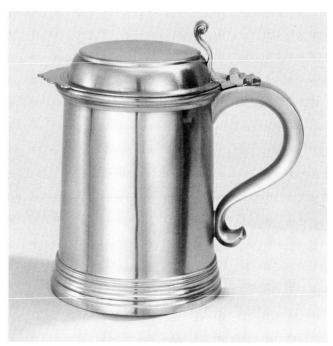

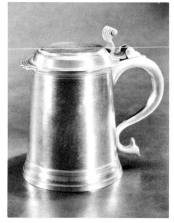

110
Pewter tankard *1930.809*
Frederick Bassett (w. 1761-1800)
New York or Hartford, 1761-1800
H. 7" (17.8 cm); Diam. base 4 15/16" (12.5 cm);
Diam. lip 4 15/16" (12.5 cm)
Yale University Art Gallery;
Mabel Brady Garvan Collection

109
Pewter tankard *1977.38*
Reed and Barton Company
Taunton, Massachusetts, ca. 1970
H. 6 5/8" (16.8 cm); Diam. base 5" (12.7 cm);
Diam. lip 4 5/8" (11.7 cm)
Study Collection, Yale University Art Gallery

In the early twentieth century a market for
reproduction pewter based on eighteenth century
styles evolved. Among the most popular forms were
mugs, tankards, porringers, coffeepots, teapots, and
plates. This reproduction tankard (109) imitates the
type of tankard made by Frederick Bassett between
1761 and 1800. However it differs from the original
(110) in appearance, execution of detail, and form.
The soft appearance of the Bassett tankard bespeaks
the old method of casting a pewter alloy that con-
tained lead and finishing the object by skimming it on
a lathe. The process of spinning lead-free sheet pewter
into a tankard form and polishing it on a buffing
wheel gives the reproduction a modern, mechanized
finish. Although these two tankards share certain
details such as a flanged cover, crenate lip, convex
molded flat top, hollow scroll handle, and scrolled
thumbpiece, the reproduction exhibits a lack of
understanding of the Bassett form. The thick molding
on the baseband, unusual bud-like handle terminal,
crudeness of the scroll thumbpiece and bulk of its
hinge, and harshness of the body's lines are atypical
of the tankards Bassett produced. The reproduction
tankard's heavy, squat proportions contrast sharply
with the architectural detail of the Bassett tankard.
ESC

111
Glass candlestick *1977.41*
Produced for the Museum Shop of the Metropolitan Museum
of Art by Imperial Glass of Ohio, Bellaire, Ohio, 1976
H. 10 5/8" (26 cm); W. 3 11/16" (9.4 cm);
D. 3 11/16" (9.4 cm)
Study Collection, Yale University Art Gallery

112
Glass candlestick *1931.1298*
Boston and Sandwich Glass Company
Boston and Sandwich, Massachusetts, ca. 1840
H. 10 1/2" (27 cm); W. 3 11/16" (9.4 cm);
D. 3 11/16" (9.4 cm)
Yale University Art Gallery;
Mabel Brady Garvan Collection

Early in the twentieth century candlesticks of this
type were reproduced in Eastern Europe for Ameri-
cans who imported them into the United States.
Although these were probably not made as fakes,
with time they began to turn up on the antiques
market as originals.[1] The American reproduction
candlestick (111) shown here represents the con-
tinuing popularity of this form and the proliferation
of inexpensive reproductions which museums now
make available to the public.

In making this reproduction the manufacturer has
endeavored to simulate the irregularities characteristic
of early Sandwich glass; the candlestick is "hand-
pressed" into iron molds through a process much like
that used in the nineteenth century. However,
numerous differences between the reproduction and
the original (112) are apparent. The color of the new
piece is substantially greener than the more delicate
canary yellow of the antique and the head of the
dolphin is solid glass which gives it less brilliance than
the old example. The new glass is also more uniform
with fewer bubbles and cracks, and is thicker at the
base and in the petals around the shaft. The dolphin's
body does not curve as sharply as in the original and
the disk between the dolphin and the candle holder is
smoother than in early examples. *BMW*

1. Ruth Webb Lee, *Antique Fakes and Reproductions*
(Wellesley Hills, Massachusetts, 1950), pp. 237-243.

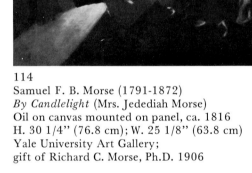

113
Charlotte Morse (Mrs. Aspinwall Hodge) 1968.3.2
By Candlelight (Mrs. Jedediah Morse)
Oil on canvas, mid-19th century
H. 29 1/2" (74.9 cm); W. 24" (61 cm)
Yale University Art Gallery;
bequest of Josephine K. Colgate

114
Samuel F. B. Morse (1791-1872) 1951.58
By Candlelight (Mrs. Jedediah Morse)
Oil on canvas mounted on panel, ca. 1816
H. 30 1/4" (76.8 cm); W. 25 1/8" (63.8 cm)
Yale University Art Gallery;
gift of Richard C. Morse, Ph.D. 1906

These two portraits of Mrs. Jedidiah Morse provide us with a good example of an original painting as compared to a contemporary student copy. Samuel F. B. Morse completed the portrait (114) of his mother during his formative years as a portraitist, possibly in 1816. Some years later Charlotte Morse, a relative, made a copy (113) of it. Samuel's painting shows a heavy use of impasto, a sensitive treatment of the sitter's face, and a keen understanding of the subject's personality. Morse's major concern in the portrait is the striking illumination of his subject by a hidden light source.

This important and compelling feature of Morse's portrait is not captured in the copy where the face does not glow as warmly and vividly. Also, Charlotte's depiction of Mrs. Morse's features is awkward; the artist delineates these areas too harshly and misunderstands Samuel's subtleties of shading, especially in the flesh tones. Charlotte Morse obviously was an artist of some skill and talent, but like many copyists she has been unable to recreate the qualities that make the original work so successful. *JB and HK*

The portrait (116) of the Reverend James Pierpont (1659-1714) by an artist known as the Pierpont Limner, provided the model for this later, unsigned replica (115). Pierpont was pastor of the First Church of New Haven from 1685 to 1714 and was also a founder of Yale College. In the original work the Reverend is depicted against a deep-brown background. The sitter is delicately and sensitively rendered. The copy, however, is at best, awkward. The background suffers from a change in color from a rich mahogany at the right side to a muddy brown in the upper left corner. Crude letters at the bottom spell out "ETAT 51" rather than the "AEtat" inscription of the original. The heavy application of paint fails to recreate the subtle flesh tones or uniform surface found in the original work. Although the copyist has reproduced an image of Pierpont, the expression of the face and particularly the broad handling of the paint reflect a traditional twentieth-century portrait style rather than that of the eighteenth century. *JB and HK*

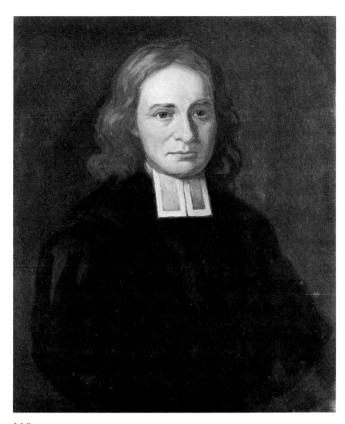

115
Anonymous
Reverend James Pierpont
Oil on canvas, early 20th century
H. 29 1/4" (74.3 cm); W. 24 1/2" (62.2 cm)
New Haven Colony Historical Society;
gift of Mrs. Paul Bohanon

116
Pierpont Limner (18th century)　　　　*1969.62.1*
Reverend James Pierpont
Oil on canvas, 1711
H. 31 1/8" (79.1 cm); W. 25" (63.5 cm)
Yale University Art Gallery;
bequest of Allen Evarts Foster, B.A. 1906

In 1965 Claes Oldenburg began making drawings for satirical colossal monuments to be placed in prominent public places. Oldenburg has transformed some of these ideas into small-scale, three-dimensional versions. However, with a few notable exceptions [such as the *Lipstick (Ascending) on Caterpillar Tracks,* 1969, now located at Yale University] the monuments have been realized only on paper.

In 1969 the printing company, Multiples, issued an offset lithographic version (117) of one of these watercolors, *Drum Set in Battersea Park* (118). The reproductions were issued as if they originally had been intended as "original" prints, in a numbered edition of seven hundred with each one signed by the artist. The print raises a key problem in twentieth-century art—defining the original work of art. Prior to the invention of offset lithography, prints were pulled from blocks, plates, stones, or stencils specifically prepared by an artist or printmaker. However, the quick and inexpensive offset process, in which a work is photographed and mechanically reproduced, does not require either the participation or direct supervision of an artist or printmaker. Because this method is more mechanical, many people question whether offset lithography is a viable form of printmaking.　*JB*

117
Claes Oldenburg (b. 1929)　　　　　　　*1973.157*
*Proposed Colossal Monument for Battersea Park, London,
Drum Set, 1966*
Offset lithograph, 1969
H. 23 3/4" (60.6 cm); W. 35 3/16" (89.4 cm)
Yale University Art Gallery;
gift of Norman Holmes Pearson, B.A. 1932

118
Claes Oldenburg (b. 1929)　　　　　　　*1973.115*
Drum Set in Battersea Park (not illustrated)
Crayon and watercolor, 1966
H. 15" (38.1 cm); W. 22" (56 cm)
Yale University Art Gallery;
purchased with the Aid of Funds from the National Endowment
for the Arts and the Susan Morse Hilles Matching Fund

Audubon's great work, the *Birds of America,* was issued in eighty installments between 1827 and 1838. Four "elephant" folio volumes contained 435 colored plates copied from his watercolors. In depicting living birds in context, *Birds of America* differed strikingly from the accepted style of ornithological illustration which showed stuffed specimens on perches.

Although his illustrations are best known today for their dramatic expressiveness, Audubon's motivation was largely scientific. He chose huge folios to be able to illustrate each bird life-sized. As in this example, he intended to show the colorings of the male and female of the species, and their usual source of food.

The medium of colored engraving was itself a link to previous scientific illustration. The hand-coloring of copper engravings was the first technical improvement in scientific engraving that accompanied an expanding interest in science in nineteenth-century America.[1] It was felt hand-coloring increased illustrations' accuracy. The complaints made to Havell

emphasize the importance Audubon gave to accurate color at this time.[2] These elephant folios formed the basis for later versions of Audubon's work. *DS*

1. Charles B. Wood, "Prints and Scientific Illustration," in John D. Morse, ed., *Prints in and of America to 1850* (Charlottesville, Virginia, 1970), pp. 169-170.
2. Waldeman H. Fries, *The Double Elephant Folio, The Story of Audubon's Birds of America* (Chicago, 1973), p. 64.

The elephant folio engravings (119) were unprofitable for Audubon, and his decision to publish the *Birds of America* as a smaller, inexpensive octavo edition was partly motivated by a desire to recover his losses. In these new editions, the illustrations were lithographed, not engraved. Rather than sold as separate prints, they were used to illustrate an earlier text.[1]

Although Audubon's desire was simply to replicate the earlier engravings, the effects caused by the cheaper process are apparent. Details are omitted,

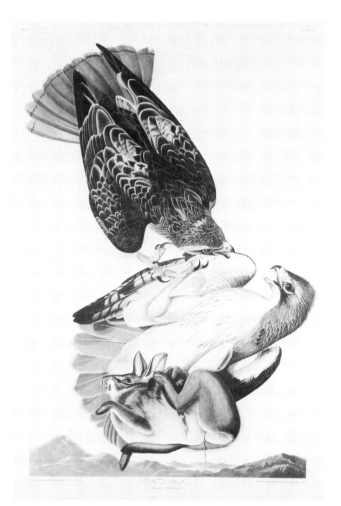

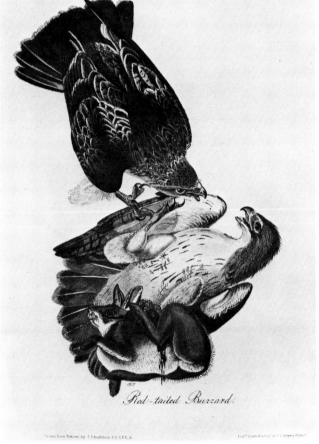

119
John James Audubon (1785-1851) *1969.101*
Red-Tailed Hawk
Engraving, by Robert Havell, London, 1829
H. 38 1/2" (96.8 cm); W. 25 1/2" (64.7 cm)
Yale University Art Gallery;
Mabel Brady Garvan Fund

120
John James Audubon (1785-1851)
Red-Tailed Buzzard
Lithograph, J. T. Bowen, Philadelphia, 1839
Image: H. 8" (27 cm); W. 5 3/4" (14.6 cm)
Beinecke Rare Book and Manuscript Library

particularly of the prey and in the background. These smaller illustrations, two examples of which are included here, lack Havell's coloristic subtlety. Audubon accepted a greater variation in Bowen's coloring than he tolerated in Havell's work, as a comparison of the *Red-Tailed Buzzard* in Havell's engraving (119), the 1839 prospectus (120), and the 1840 counterpart (121) shows. *DS*

1. Audubon's *Ornithological Biography*, published from 1831 to 1839 in Edinburgh, formed the text to this octavo edition of *Birds in America*.

121
John James Audubon (1785-1851)
Red-Tailed Buzzard (not illustrated)
Lithograph, J. T. Bowen, Philadelphia, 1840
Image: H. 8" (27 cm); W. 5 3/4" (14.6 cm)
Beinecke Rare Book and Manuscript Library

In 1831, Audubon arranged for Joseph Bartholomew Kidd, a Scottish landscape painter, to copy in oils the illustrations to the first volume of *Birds of America* and add backgrounds. Supposedly only eight were finished before their agreement was dissolved the same year. However, one of Audubon's own ledgers records that he received ninety-four oil paintings from Kidd between 1832 and 1835. Fifty-eight similar oil replicas have presently been located, but whether they are by Kidd or Audubon is still open to question.[1]

This oil painting (122) of the *Red-Tailed Hawk* (which appeared in the first volume) is presently attributed to Audubon's own hand. The background

is given a degree of detail that appears on neither Havell's engraving nor on the original watercolor. By emphasizing a lofty context, the background intensifies the illustration's inherent drama.

The chromolithograph (123) was issued in response to John Woodhouse Audubon's proposal in 1858 or 1859 to make full-scale replicas of his father's elephant folio engravings. He chose chromolithography to cut the original production costs in half. The designs were transferred directly from Havell's copper plates, and reproduced with mechanical accuracy. The Chief difference between this and Havell's engraving (119) lies in the coloring. Like the oil painting, the scene has a dramatic quality greater than in the original engraving. It is achieved here by the addition of blue sky and a suggestion of clouds. The deviation in coloring indicates the chromolithograph was not intended as a true to life illustration. *DS*

1. Waldeman H. Fries, *The Double Elephant Folio, the Story of Audubon's Birds of America* (Chicago, 1973) pp. 363-364, 366.

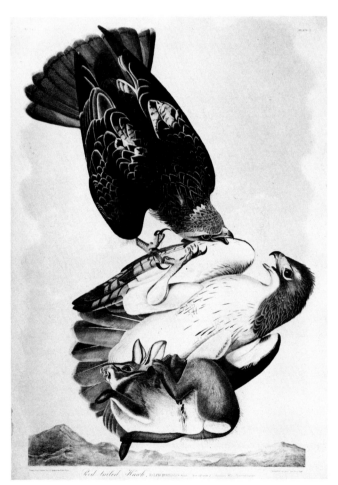

123
After Audubon
Red-Tailed Buzzard
Chromolithograph, J. Bien, New York, 1860
H. 41" (104.1 cm); W. 28" (71.1 cm)
Beinecke Rare Book and Manuscript Library

122
John James Audubon (1785-1851) *1951.21.1*
Red-Tailed Hawk
Oil on canvas, ca. 1831
H. 38" (96.5 cm); W. 25" (63.5 cm)
Yale University Art Gallery;
Exchange and Mabel Brady Garvan Purchase Fund

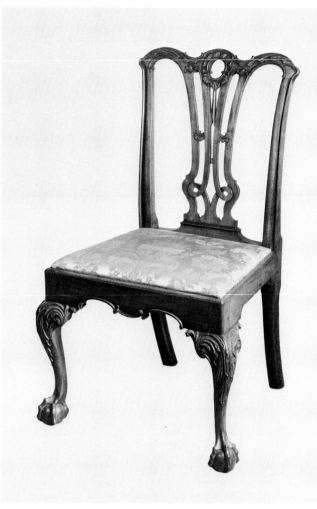

124

Questionables

All works of art that "fooled" collectors in the past were considered questionable for at least a short time before their true identity was discovered. Often in-depth study of the questioned object reveals idiosyncracies of construction or design which are inconsistent with the products of a given period, artist or place. But in some cases even the most critical examination of objects by art historians and scientists has not resulted in a positive identification. As in the example of the labeled Benjamin Randolph chair (124) at the Museum of Fine Arts, Boston, experts often can express widely differing opinions as to the age and authenticity of an object.

In the case of the fine arts (paintings, works of art on paper, and sculpture—objects which have traditionally been associated with specific artists), the authenticity of the work of art and the identity of the artist are the major questions to be answered. The place of origin of a work in the fine arts is often considered of no great importance, primarily because it does not affect the attribution of the work to a particular artist. In the decorative arts (furniture,

silver, textiles, and glass, for example) determination of the place of origin of an object is one of the important elements of identification. Canadian and European decorative arts are difficult to differentiate from those produced in this country. The correct attribution of silver and pewter objects, an important consideration, is often facilitated because they bear makers' marks; the identity of the makers of furniture is more difficult because comparatively few pieces are labeled or otherwise marked.

There are different opinions among art historians on how works of art should be examined and evaluated. The most common approach involves connoisseurship; the application of science to the study of objects has been more recently introduced. Traditionally the connoisseur has relied upon his knowledge of the stylistic and structural characteristics of works of art to determine their authenticity, authorship and place of origin. Although the connoisseur uses measurements and magnification, the scientist, a relative newcomer to the field of art, expands the information available to the connoisseur through the use of modern tools and methods such as microscopy, spectroscopy, x-rays, ultraviolet and infrared light.

Ideally the modern study of the history of art combines the skills of the traditional connoisseur and the scientist. Such a combination is necessary to provide a bank of technical information for the future evaluation of related objects. The collaboration between science and connoisseurship also exposes the shortcomings of fraudulent works of art. The bronze Greek horse at the Metropolitan Museum of Art, previously dated to the fifth century B.C., is an example of such a fake. After the authenticity of the object was called into question, the cooperation between science and art history revealed, through x-ray photography, that the method and materials used in its construction were not developed until the fourteenth century.[1]

According to Charles Montgomery, the true connoisseur is a skeptic.[2] All objects being considered for purchase by a collector must initially be seen as questionable and thoroughly examined and studied from every possible viewpoint. Attributions should not be made on the basis of details only, but on all the facts presented by the object. In painting, for instance, the use of certain pigments or the way a canvas is prepared can be just as suggestive of the work of an artist, time or place as the mood of the painting, its subject matter, or the brushstrokes used in its execution. Likewise, in the study of furniture, such factors as the woods employed, the style of carving, and construction features should not be the only basis for attributions. Montgomery, in his essay "Some Remarks on the Science and Principles of Connoisseurship" lists thirteen exercises which provide information for the final evaluation and

appraisal of an object. These involve considerations of the object's overall appearance, form, ornament, color, materials, construction techniques, function, style, date, attribution, history and condition, as well as a knowledge of the trade practices of the period in which the object was supposedly made.[3]

The study of works of art is an ongoing process and objects in both public and private collections are constantly being reevaluated by historians. Even after the most discriminating scientific and stylistic study and evaluation of works of art, it is not always possible to determine their authenticity, or place of origin, or authorship. A lack of knowledge of related objects makes a decision about the work of art under consideration impossible. Differences in the interpretation of evidence make an attribution certain to one expert and questionable to another. Certainly, the questioning of attributions of works of art leads to new research which in turn leads to new questions and, hopefully, to the confirmation or rejection of current attributions.

Francis J. Puig

1. Joseph V. Noble, "The Forgery of Our Greek Bronze Horse," *The Metropolitan Museum of Art Bulletin* 26, no. 6 (1968): 253-256.
2. Charles F. Montgomery, "Some Remarks on the Science and Principles of Connoisseurship," *The Walpole Society Note Book* (1961), p. 8.
3. Montgomery, pp. 9-20.

The labeled Benjamin Randolph chair (124) in the Karolik Collection at the Museum of Fine Arts, Boston, is one of the most controversial pieces of American furniture. Because of atypical construction features, coloring which is unusual for a chair of the eighteenth century, and a questionable label, experts have been unable to agree on an attribution for it. Among the possibilities suggested are that the label on the chair is authentic but that it has been placed on a totally fraudulent piece, that it is a revival piece altered in some manner, and that it is a genuine Philadelphia chair by another maker.[1] The fact that there are no other chairs of this type labeled by Benjamin Randolph does make its attribution to him questionable. Only seven other chairs bear his label; six of these were exhibited at the New Jersey State Museum in 1929,[2] the other (125) is exhibited here. The differences in proportion, ornament and construction between these chairs and the example in the Karolik Collection (124) are great. To some, the simplicity of these chairs calls into question the attribution to Randolph of ornate pieces of furniture. *FJP*

1. For a summary of the various arguments on these chairs see John T. Kirk, *American Chairs: Queen Anne and Chippendale* (New York, 1971), pp. 172-174.
2. For an illustration of these chairs see Samuel W. Woodhouse, Jr., "More About Benjamin Randolph," *Antiques* 18, no. 1 (1930), p. 21.

The design of the back of these chairs was derived from plates XIII and XIV in Thomas Chippendale's *The Gentleman & Cabinet-Maker's Director* (London, 1754). American chairs of this type are often attributed to Benjamin Randolph on the basis of their similarity to a chair with his label at the Museum of Fine Arts, Boston (124). However, the first chair (126) in this comparison is probably not of American origin. Although it is certainly like the Philadelphia example illustrated here (127), the handling of its elements raises the possibility that it is of Spanish or Portuguese manufacture. This supposition is suggested by the stiffness of the cabriole legs, the design of the carving on the knees, the flatness of the ball and claw foot and the use of stretchers (now removed) between the front legs and stiles. These features are characteristic of baroque and rococo furniture from Spain, Portugal and their colonies.[1] Although it is possible that the chair was produced in Philadelphia by a craftsman trained in Spanish or Portuguese chair-making traditions, because Chippendale's designs were disseminated so widely it is more likely that the chair was made in Europe. *FJP*

1. See Marques De Lozoya, *Muebles de Estilo Espanol* (Barcelona, 1962), plate 255 and A. Taullard, *El Mueble Colonial Sudamericano* (Buenos Aires, Argentina, 1944), figures 10, 23, 28, and 30.

124
Side chair (see p. 86)
Possibly by Benjamin Randolph (active 1760-1782)
Possibly Philadelphia, 1760-1782
Mahogany
H. 38 3/8" (97.5 cm); W. 23 3/4" (60.3 cm);
D. 19" (48.3 cm)
Museum of Fine Arts, Boston;
M. & M. Karolik Collection

125
Side chair (not illustrated) *1930.2495*
Benjamin Randolph (active 1760-1782)
Philadelphia, 1760-1780
Mahogany; Atlantic white cedar
H. 37" (94 cm); W. 22 5/8" (57.5 cm);
D. 19 1/16" (49.7 cm)
Yale University Art Gallery;
Mabel Brady Garvan Collection

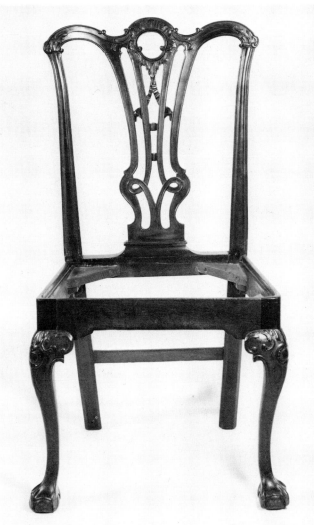

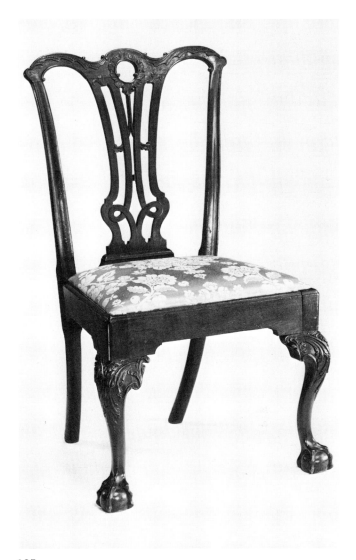

126
Side chair
Possibly American, possibly Portuguese or Spanish,
possibly 1760-1780
Mahogany
H. 38" (96.5 cm); W. 22" (55.9 cm);
D. 18" (45.7 cm)
Museum of Fine Arts, Boston;
bequest of Miss Ellen Starkey Bates

127
Side chair *1930.2102b*
Philadelphia, 1760-1780
Mahogany; tulip, Atlantic white cedar, pine
H. 38 3/4" (98.4 cm); W. 21 1/8" (53.7 cm);
D. 17 1/8" (43.5 cm)
Yale University Art Gallery;
Mabel Brady Garvan Collection

128
Unknown
Beach Scene
Oil on canvas, 1890-1900
H. 11 3/4" (29.9 cm); W. 17 1/2" (44.5 cm)
Private Collection

The style and subject matter of this unsigned oil painting are typical of the late nineteenth century, and the canvas is of an old, heavy weave used in this period. The work appears to be in its original frame. The problem is—who painted it? At first glance it seems to be of sufficient quality to have been done by either Winslow Homer (1836-1910) or William Merritt Chase (1849-1916). The beach cliff setting, bright color tones, direct quality of light, and the composition incorporating isolated groups of figures are closest in style to Homer's paintings such as *Long Branch, New Jersey,* 1869 (Museum of Fine Arts, Boston) and *Enchanted,* 1874 (Collection of Mrs. Harold Wendel). Yet the loose, fluid brush strokes in the foreground are similar to those used by Chase in his beach picture, *Shinnecock, Long Island,* ca. 1895 (Princeton).

It seems unlikely, however, that the painting is by either Homer or Chase. Although parts of the picture, especially the figures, are competently painted, the handling of space, particularly in the middle distance, is somewhat ambiguous. Most likely, the painting is

the product of a student of Chase, perhaps one he taught at the Shinnecock School (1891-1902). If so, the artist seems to have been familiar with Homer's work, quoting both his subject matter and settings of the 1870s, but using Chase's style of brush work. *JB*

Purchased from a London shop in 1950, this portrait (129) was though to be a lucky find depicting Whistler's friend, the actress Ellen Terry. However, although it resembles a photograph of Terry, it is unlike John Singer Sargent's portrait of the actress,[1] and Terry's son considers the pastel neither a portrait of his mother nor a work by Whistler.[2]

The portrait can also be questioned on stylistic and technical grounds. Whistler often drew on brown papers, but his use of a cloth support for pastels is unrecorded. He usually outlined his subject crisply with black chalk before adding colors between the lines. He seldom stumped pastels, preferring to treat the sticks of color as drawing tools, retaining the sense of line. This technique, evident in Yale's

Venetian view (130), is absent in the Terry portrait. Stumped colors blend softly in the hair and face, little sense of underdrawing remains, and the portrait is less linear than one would expect in a genuine Whistler. In most Whistler portraits the head is rendered smaller and further from the picture plane than we see here.[3] The head's tilt and sharp profile are remarkably similar to the subject of a Whistler oil, which could conceivably have inspired the maker of this pastel.[4]

Pastel is a fragile medium, yet the portrait is neither smeared nor smudged. Its "butterfly" signature seems coeval with the drawing, but is timid and faint in comparison to the Yale pastel's vigorous "butterfly." There is little reason to suppose that Whistler—never a modest man—would not have signed this portrait boldly had he actually drawn it.
DPC

1. See Richard Otman, *John Singer Sargent: Paintings, Drawings and Watercolors* (New York, 1970), fig. 45, p. 83 and plate 52, p. 245.
2. E. Gordon Craig (Terry's son) to present owner, 13 August 1952.
3. Thomas E. Beggs, National Collection of Fine Arts, to the present owner, 16 August 1950.
4. *Arrangement in Black and Brown: the Fur Jacket*, exhibited in London in 1877, and illustrated in Denys Sutton, *Nocturne: The Art of James McNeill Whistler* (London, 1963), p. 76.

129
Attributed to James McNeill Whistler (1834-1903)
Portrait of Ellen Terry
Black chalk and pastels on tan fabric
H. 10 9/16" (26.8 cm); W. 8 9/16" (21.7 cm)
Collection of Arthur G. Altschul

130
James McNeill Whistler (1834-1903) *1966.9.27*
Venice: View of the Salute and the Redentore
Black chalk and pastels on brown paper, ca. 1880-1881
H. 5 1/2" (14 cm); W. 10 1/2" (26.7 cm)
Yale University Art Gallery;
Mary Gertrude Abbey Fund

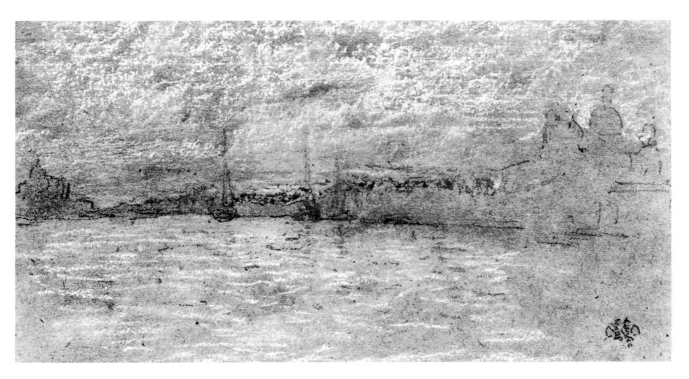

A Note on the Scientific Examination of Works of Art

Many are the marriages between art and science—from the mathematically precise theories of perspective developed during the Renaissance to the intricate color theories of the nineteenth century. A most successful marriage of convenience began late in the nineteenth century when scientific testing and methodology began to find application in the analysis and conservation of artworks. This scientific testing offers a significant supplement to the connoisseur's expertise, by providing information about the materials in the object which help to determine its date or authenticity, to establish its maker's identity, or its place of manufacture.[1]

Tools and techniques of examination divide into non-destructive and destructive methods. An artwork is not altered in any way by non-destructive techniques. Destructive methods require samples—albeit ever more minute—which are changed or consumed during testing.

Examination of an artwork begins with the unaided eye in natural sunlight to determine general condition, consistency of design, quality of color or patina and so on. For example, raking light across the surface of a painting can reveal surface irregularities which might indicate retouching. Looking at the object through a pocket lens, 6X to 10X magnification being most effective, one may find cracks which have been blurred or painted over, furniture joints half-hidden with varnish, or the inked lines that have strengthened a weak impression of an engraving. The common laboratory microscope with a magnification of 15X to 30X is useful for viewing condition in depth, and is also used when removing samples from the object for more complicated tests.

Ultra-violet light provides a simple non-destructive look at the object's surface—it can go no deeper. Colors which are chemically dissimilar fluoresce differently under U-V light. U-V can be applied to paintings, prints and drawings, textiles, glass, ceramics, enamels and marbles, but it is not particularly effective on metal objects unless a varnish patina has been added.[2] Under U-V old varnish looks like milky haze and retouchings appear as dark blotches if they were added on top of the varnish, as in a false signature inscribed on an old painting. Differences in fluorescence can indicate artificially added areas of patination on a repaired chest or chair. The color of visible light emitted by glass objects examined under U-V varies in color and intensity depending mainly upon the chemical composition of the glass. This has been useful in identifying Amelung glasswares.[3] "True ultra-violet" light can be used only with the visible light screened out, and requires a camera with filter. Less helpful than ordinary U-V, it is infrequently called upon.

Infra-red light gets slightly below the surface of the object and can reveal changes in design or a buried signature. Anyone can photograph an artwork using a camera loaded with infra-red film. A related technique is Infra-red Luminescence, which requires blue-green filtered cameras to photograph art objects. This process is better able to penetrate thick varnish layers, and has been applied specifically to examination of restored paintings and altered documents.[4]

A mercury lamp used without a filter can expose details in very dark areas of paint while light from a sodium lamp penetrates varnish layers to get at underlying surfaces.

X-rays comprise one of the most dramatic and widely-known, if over-rated, non-destructive tests. While it cannot tell all, an x-ray examination will reveal the "skeleton" of a painting in an x-ray photograph or "shadowgraph." A shadowgraph is made by laying a photographic film on the picture and sending x-rays through it from the back.[5] Because layers are superimposed, x-rays can provide only general information about the structure of a painting, yet they do detect such tricks as false craquelure—where the crackle pattern of old paint has been artificially added and doesn't run through all layers down to the support.[6] Of great value is the x-ray's ability to clarify an artist's method: "x-rays . . . help the explorer of paintings to find out otherwise hidden facts about the way a certain master has built up his work, perhaps in several layers, and they may reveal or accentuate certain peculiarities which can be of great help to the style critic and art historian."[7] Neutron activation autoradiography yields photographs, however, autoradiography records information about many pigments, not just those which contain mainly white lead.[8]

Scientists have been keenly aware of the anxiety aroused by methods labeled "destructive" in which samples must be taken. During the nineteenth century, when chunks of pigment were scratched off painted surfaces for analysis, the term was more deserved than it is today. Extremely tiny samples, often removed with a hypodermic needle, are now adequate. As a case in point, the electron microbeam analyzer can perform complete qualitative and quantitative tests of fragments much smaller than a pinhead, and specimens can be recycled for further testing with different equipment.[9] These analytical methods obtain increasingly accurate information about artists' materials.

In wet chemical analysis, now somewhat old-fashioned, a sample is dissolved in a solution which is then submitted to a series of chemical reactions to determine the specimen's make-up.

A monocular microscope with a range of 40X to 200X magnification is the standard tool for reading specimen slides to identify woods, textile fibers, and characteristic brush strokes. Microscopic analysis of wood samples has been helpful in distinguishing

English from American furniture. However, scientifically obtained information on woods must be combined with hisotrical knowledge of trading patterns. For example, American walnut was imported by England so the presence of Virginia walnut in English furniture is not unknown. Embedded in plastic, cross sections of the layer structure of a painting offer permanent records of an artist's technique. Photomicrographs can be obtained by attaching a camera to the microscope.[10] Photomicrographs showing minute details of an artist's brushwork were used as early as the 1930s.[11]

Various spectrographic processes, which rely upon the fact that all elements in the periodic table have characteristic frequencies or light wavelengths, are employed on objects of all kinds. With some methods it is possible to determine the compounds (combinations of elements) making up a material, while for others only the elements are determined. Such information is quite helpful in dating works with regard to the history of pigments. A spectrum obtained with neutron activation analysis of pigments can answer such questions as, "Is a green pigment in a painting malachite (ancient), chrome green (nineteenth century) or phthalocyanine green (a modern dye)?"[12]

Various isotopic methods have been used to authenticate objects of artistic and archeological importance. Radiocarbon dating—carbon-14—is perhaps the most famous. Carbon-14 dating can be used in the detection of forged modern paintings. Materials similar to those used by nineteenth-century artists are often still available to today's faker. Fortunately, such materials as wood, paper, canvas and linseed oil are organic and contain carbon-14. Because of nuclear testing the concentration of carbon-14 has doubled since 1900, with the sharpest rise coming immediately after World War II. High levels of carbon-14 in painting materials indicate that the work is but a few years old.[13]

X-ray diffraction analysis can identify inert components of gesso grounds by distinguishing between different crystalline forms. Changes in the crystal structure of metals often tell the story of what processes—as forging versus casting—the object has undergone.[14]

Chromatography is used to identify painting media, varnishes, solvents and organic pigments, while the Lovibond Tintometer and visual spectrophotometers are used to record differences of color such as those due to cleaning or fading.[15] In laser spectrography a laser beam vaporizes a tiny sample slightly larger in diameter than a human hair. The vapor is then analyzed on a spectrograph.[16] All these techniques are important not only for understanding the materials of art in historical terms, but also for competent decisions regarding repair and conservation.

Analyses formerly obtainable only through time-consuming destructive methods have recently been made using x-ray fluorescence spectrometry. This rapid non-destructive technique takes only a few minutes per test. At last large bodies of comparative data on artists' use of materials over time are becoming available. The technique conjoins "radioactive x-ray emitting isotopes, solid state x-ray detectors, mini-computers and compact data storage devices." X-ray bombardment excites atoms within the material being analyzed, causing them to emit characteristic patterns of secondary x-rays which lead to identification of chemical elements and their concentrations within the object. As a rather dramatic example, a silver tankard, supposedly ca. 1771-1791, was shown to be a twentieth-century assemblage, for there were no traces of gold or lead in the body. Every tested piece of silver made before 1890 has lead and gold traces within it.[17] The x-ray analyzer is used to study not only metals, but also ceramics, glass and pigments.

Not all applications of science to art occur in the laboratory. Information gathered and analyzed systematically has been revealing about regional characteristics of Federal furniture.[18] A current use of statistical methods involves computerization of 176 elements of decoration, ornamentation, construction and materials in American card tables (9, 10). This method may well prove applicable to other studies of regional differences in furniture where large amounts of data must be digested before any clear patterns emerge. The computer is also serving a new role in research and record keeping. The National Collection of Fine Arts at the Smithsonian Institution has undertaken an inventory of American paintings executed before 1914.[19] This data bank will eliminate some of the drudgery of locating works scattered across the country. A number of major museums now utilize computerized curatorial records.

Scientists continue to develop new materials like acrylic varnishes that protect everything from building facades to paintings, new conservation methods as aluminum backings for fragile canvases (40) or neutron bombardment to recover faded photographic images, temperature-humidity controls, and special lighting such as the filtered natural light in the Yale Center for British Art.[20] With contributions like these, scientists help to ensure the continued survival of our artistic heritage.

The application of science to works of art provides a body of evidence which the art historian must evaluate along with visual and documentary information. Ever increasing in sophistication, scientific instruments offer a formidable battery of tests far more sensitive than the human eye. Yet it is the eye that must read the results, the mind that must interpret them. Scientists engaged in the study and conservation of artworks are the first to agree that without highly developed connoisseurship their own labors are lost. There is, after all, no substitute for the educated eye of the beholder.

David Park Curry

1. Helmut Ruhemann, *The Cleaning of Paintings: Problems and Potentialities* (New York, 1968), p. 118.

2. James J. Rorimer, *Ultraviolet Rays and Their Use in the Examination of Works of Art* (New York, 1931).

3. Robert H. Brill and Victor F. Hanson, "Chemical Analyses of Amelung Glasses," *Journal of Glass Studies* 8 (1976): 217.

4. F. Bridgeman and H. H. Gibson, "Infra-red Luminescence in the Photographic Examination of Paintings and Other Art Objects," *Studies in Conservation* 8, no. 3 (August 1963): 77-83.

5. The process is explained in Ruhemann, p. 127. One problem is that such structures as cradles on panel paintings can almost obscure the layers of paint since a cradle registers as a dark grid in the shadowgraph.

6. W. Froentjes, "Criminalistic Aspects of Art Forgery," *Aspects of Art Forgery* (The Hague, 1962), p. 47.

7. Ruhemann, p. 129.

8. Bernard Keisch, *Secrets of the Past: Nuclear Energy Applications in Art and Archaeology* (Washington, 1972), pp. 92-93.

9. John T. Norton, "Metallography and the Study of Art Objects," in *Application of Science in Examination of Works of Art, Procedings of the Seminar, September 7-16, 1965, Conducted by the Research Laboratory, Museum of Fine Arts, Boston* (Berlin, 1967), p. 15 (hereafter cited as *Application of Science, 1965*). Composition often varies in different parts of the object, requiring multiple samples. This is especially problematic in alloy metals because elemental segregation may occur. Hence, a single reading may not be representative of the whole.

10. Ruheman, p. 131.

11. See for example E. P. Laurie's *The Brushwork of Rembrandt and His School*, published in 1932.

12. Keisch, p. 90. See also Otto Kurz, *Fakes* (New York, 1967). For chronological compilations of artists' materials, see books as R. D. Hartley, *Artists' Pigments 1600-1835* (London, 1970) and particular studies as Ernst Ludwig Rubler and Heide Härlin, "A Nineteenth-century Collection of Pigments and Painting Materials," *Studies in Conservation* 19, no. 2 (May 1974): 76-82.

13. Keisch, p. 88.

14. Cyril Stanley Smith, "The Interpretation of Microstructures of Metallic Artifacts," *Application of Science, 1965*, pp. 20-52.

15. Ruhemann, pp. 131-134.

16. Brech and Young, "The Laser Microprobe," *Application of Science, 1965*, p. 230.

17. Victor F. Hanson, "The Curator's Dream Instrument," *Application of Science in Examination of Works of Art, 1970 Seminar Procedings* (New York, 1973), p. 27. See also Hanson, "Chemical Analyses of Glasses Attributed to John Frederick Amelung," *Journal of Glass Studies* 8 (1976): 219-220.

18. Charles F. Montgomery, *American Furniture: The Federal Period* (New York, 1966), pp. 27-40.

19. *Directory to the Bicentennial Inventory of American Paintings Executed Before 1914*. This book, which outlines the Inventory's holdings and shows how to use them was published for the National Collection of Fine Arts, Smithsonian Institution, by the Arno Press, New York, 1976.

20. G. G. Amoroso and V. Furlan, "Utilisation de rosines acryliques pour la protection superficiele de grès tendres," *Studies in Conservation* 20, no. 1 (February 1975): 2-7.